THE ESTHETIC BASIS OF GREEK ART

A Midland Book

INDIANA UNIVERSITY PRESS

BLOOMINGTON

THE ESTHETIC

BASIS OF

GREEK ART

OF THE

FIFTH AND FOURTH

CENTURIES B.C.

RHYS CARPENTER

FOREWORD

THE PRESENT VOLUME is a critique not of artistic taste but of artistic behavior. It makes no attempt to eulogize or appreciate or evaluate ancient Greek art, but solely to examine Greek artistic procedure and by such an examination to arrive at some fundamental esthetic problems and principles.

Such a study, since it tries to be fundamental, must aim at a method sufficiently general to be applicable not to Greek sculpture only, but to sculpture in all times, and not to Greek architecture alone, but to architecture the world over. The chapters which deal with these arts overpass, therefore, the boundaries of Hellenic antiquities and attempt an esthetic critique of sculpture and architecture as human (and not merely as Grecian) artistic activities. But the starting-point for theorizing has always been Greek practice. A comparable remark would apply to Greek painting, were it not that total destruction of its reputed masterpieces has made its understanding too debatable for reliable argument. With regret, therefore, I have refrained from adding a chapter on painting and have confined myself to passing reference to fifth century vase drawings.

Those who are familiar with the little of value which ancient esthetic speculation offers, will have noticed that the most useful comes, not from the philosophers, but from the

practicing artists and their chroniclers. There is, however, more to be drawn from Plato than I have included—a deliberate omission where much mistaken modern comment would first need to be cleared away. For the rest, I have tried to utilize every indication of the intellectual attitude of the ancient artists toward their craft.

The present edition does not materially differ from the original printing which appeared in 1921 as Volume One of the Bryn Mawr Notes and Monographs. A few verbal changes have been made in the interest of clarity; here and there a paragraph has been expanded or some brief new observation added. Greek words have mostly been expunged, though Latin have been retained. The archaeological discoveries and the heightened specialization of the three decades since the text was first written have not required much alteration in a discussion which aimed to be basic, generic, and—if possible— of unrestricted reference. The marginal rubrics of the earlier edition have been omitted; a topical index has been added; and a very brief bibliography appended. More helpful, perhaps, will be the addition of a selected few illustrations, appropriate to illuminate a text which otherwise might seem too remote from its visual subject-matter.

I express my warmest thanks to the authorities of the Indiana University Press for deciding to rescue my book from the obscurity to which the early exhaustion of the original limited edition had for so long consigned it.

R. C.

"Jerry Run"
April, 1959

CONTENTS

ILLUSTRATIONS

THE ESTHETIC BASIS OF GREEK ART

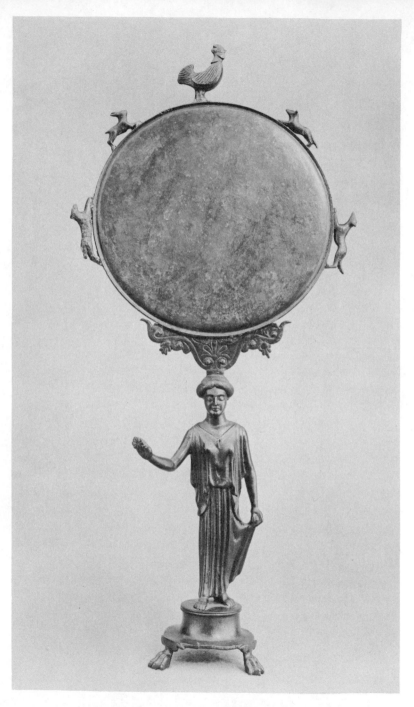

Bronze Mirror. Leipzig, Kunstgewerbe Museum.

I

THE SUBJECT-MATTER OF
GREEK ART

SPECIMENS OF GREEK HAND-MIRRORS may be found in any of the great museums of classical art. The worn and patina-covered disk was once a plate of burnished bronze. To it was fastened a handle, often terminating in a base on which the mirror could be made to stand upright. A circle to reflect the circle of the human face, a handle by which to grasp and turn the disk, a support on which to stand it—these three elements arose out of service for which mirrors are made. With the Greeks, art was closely wedded to mere utility; and the modern museum-goer can discover something of the essential behavior of Greek art if he pauses to see what the ancient artist contributed to these three utilitarian elements of an old-time looking-glass.

Disk, handle, and base—a circle, a shaft, and a spreading bottom—joined and made one, since all are parts of the same mirror. Joined, but how? By rivets, usually. But these are mere material links, holding disk to handle and handle to base. But how to join a circle to a columnar shaft and this in

turn to a spreading stand? It is easy to fuse the matter; but how shall we fuse the form? The straight boundary-lines of the shaft should swing out and curve and in their curve go over into the disk's full circle; the broad bottom of the stand should rise up and narrow to the shaft's straight ascent. By some sort of geometric transition each characteristic shape must pass over into the adjoining one, and a continuity of outline must hold all three forms together into one.

This is simple and good, so far; but is there no more to do? Are the surfaces within these interflowing boundary-lines to be left unformed? If the shaft holds up the disk, it can make that service comprehensible to us not merely by the patent facts of gravitational support, but in a more direct visual manner.

Perhaps the most effectual way to suggest to the beholder this function of support would be to model the shaft into the likeness of a human being who carries the disk upon his head. Looking at such a representation, one could hardly fail to appreciate the relation between shaft and disk. We might claim that gravitation had been as it were visualized and given to us directly by a sympathetic analogy. Another way to suggest this function of support might be to seek an analogy with architecture and to carve the shaft like a fluted column. Our apprehension would then be less immediate, perhaps, since the appeal to human experience is no longer direct; but there might be a compensation in the up-and-down of the fluting-channels and the emphatic simple shape divested of all irrelevant associations. Best of all, these two methods might be combined. The shaft could be modeled as a human figure architecturally formalized by means of vertical ridges and channelings and a general column-like outline. Then the appeal would be two-fold: a linear unpictorial suggestion bor-

rowed from architecture would be fused with an animate representation, and both would be perfectly consonant with the simple mechanical function of a mirror-stand.

There would remain only the transition from the shaft to the disk, to be "animized" and presented in some sort of pictorial analogy. On a mirror in the Metropolitan Museum in New York, two little winged love-gods fly above either shoulder of the central figure and thereby carry the outline over into the curve of the disk, spreading the rectilinear shaft out into a circle. To justify the occurrence of these Erotes, the human-figured shaft has become Aphrodite, whose presence upon a mirror-support needs no excuse. So, everything has been taken into account—structure and shape and meaning and use—and the result is not a mere blind embellishment to make prettiness out of plainness, but an ordered, consonant, and intellectual humanization of a number of abstract and not exactly obvious properties and relations.

And therein, it would seem, lies much of the characteristic behavior of Greek art—in rethinking certain essential matters of structure, purpose, and fitness, and in reembodying them in a fusion of geometric form with pictorial illusion.

"A charming thing!" comments the museum-goer who pauses to look at the old mirror. But it is not really a question of charm; it is a question of a language which speaks through the eye instead of through the ear, but appeals just as insistently and directly to the intelligence and the emotions of the stirred imagination as do the spoken syllables of intelligible speech. As a product of artistic craftsmanship, it was made not for a vague delight, but for sharp and definite emotional comprehension. It is not such stuff as dreams are made on, but a product of logical thought of a very particular bent, inventing a

visual embodiment for itself (in conformity, be it added, with a sense for loveliness).

Into the inner workings of this "sense for loveliness" it is difficult to penetrate. Esthetic philosophy has wasted its energy in rather *a priori* and abstract discussions of the nature of beauty. It has perhaps succeeded in defining its realm, but it has scarcely managed to reduce it to anything other than itself. Beyond the restrictions of such theorizing, the canon of taste continues to operate according to its own good pleasure.

But if we are determined not to enter upon discussions on the nature of the beautiful in art, but confine ourselves to examining the working of this "logical thought of a very particular bent, inventing a visual embodiment for itself," we shall be dealing with a more intellectual process amenable to intellectual analysis, about which words can be written and read and definite ideas formulated. We shall find that we are dealing with something very concrete and very tangible, concerning which statements may be made with a content demonstrably true or false. By means of such an inquiry we shall not be able to answer the question, "What constitutes *good* art?" but we should be able to reply intelligently and definitely to the question, "What does the artistic process do? how does it behave?" In the specific field of ancient Greek art, this is the question to which this book attempts an answer.

The impulse which drives man to employ imitative art for the purpose which we call decoration—apart from those utilitarian ends which magic or superstition may suggest—is (apparently) the desire to animate the inanimate and fill the unliving world with living forms. It would seem that this might be only another manifestation of that tendency to re-

gard everything as an animate agency which is at the back of most religious superstition. Just as the primitive man peoples his stones and trees, his hills and rivers, with living spirits having always more or less human forms and passions, until the physical world of unfeeling objects about him lives for him as a more intelligible (even though not always more companionable) place of humanized demons, so the craftsman artist seizes upon inert wood and stone and metal, and converts it into the likeness of animate things, that he, too, may raise the lifeless to guise of the living. To imagine a spirit in every tree and rock and fountain-head and cave and stream, and to see a resemblance to a living creature in every chance outline and surface and pattern—these are scarcely one and the same. But it may be that both hark back ultimately to the same primitive instinct. The child makes persons out of the senseless furnishings of his nursery, as the savage can make persons out of his environing objects and, with fear and failure working on him, can beget him a fearful theogony. But where the savage takes his animism for terrific and malevolent truth and believes in all the spirits of wind and corn, there is always in art this reassuring measure of sophistication, that craftsman and public know that what is imitated is not truly real, but a work of untyrannized fancy.[1] The artist, working for delight and not from fear, gives us again the child's pleasure of peopling our dull surroundings with interesting and kindly life; and with this simple pleasure we fuse those more intelligent and thoughtful delights that come with artistic contemplation.

This conversion of things whose shape is but arbitrary and conventional into the illusion of nature-given shapes of living things plays upon us with a thrill that I can best illustrate by offering an instance of the converse process of converting the

chance outlines of living things into the stately, immovable, and unbetterable contours of a shape of art. A poet, seeing girls with water-jugs on their heads, has written:

> Voici bien, O Jacob, le geste dont tes filles
> Savent, en avançant d'un pas jamais trop prompt,
> Soutenir noblement l'amphore sur leur front.
> Elles vont, avec un sourire taciturne,
> *Et leur forme, s'ajoute à la forme de l'urne,*
> *Et tout leur corps n'est plus qu'un vase svelte, auquel*
> *Le bras levé dessine une anse sur le ciel!*

Much of the wizardry of poetry rests upon this same instinct for animizing the inanimate by discovering analogies with living things or informing formless things with familiar shapes:

> He will watch from dawn to gloom
> The lake-reflected sun illume
> The yellow bees in the ivy bloom,
> Nor heed nor see what things they be;
> But from these create he can
> Forms more real than living man,
> Nurslings of immortality!

One might almost maintain that it is the poet's office (like the artist's) to animate the dead world, his medium being, instead of direct visual presentation, the verbal suggestion attaching to epithet, analogy, and metaphor. The truth of such a statement would of course have to be proved by an appeal to the whole *corpus poeticum;* but it may be briefly substantiated by quoting a strophe of Shelley's *Ode to the West Wind* as an

outstanding instance of this envitalizing instinct of the poetic
art:

> O wild West Wind, thou breath of Autumn's *being*,
> Thou, from *whose* unseen *presence* the leaves dead
> Are driven, like *ghosts* from an *enchanter fleeing*,
> Yellow, and black, and pale, and hectic red,
> *Pestilence-striken multitudes:* O thou,
> Who *chariotest* to their dark wintry *bed*
> The *wingèd* seeds, where they lie cold and low,
> Each like a *corpse* within its grave, until
> Thine azure *sister* of the Spring shall *blow*
> Her *clarion* o'er the *dreaming* earth, and fill
> (*Driving* sweet buds like *flocks* to *feed* in air)
> With living hues and odours plain and hill:
> *Wild Spirit,* which art moving everywhere;
> *Destroyer* and *preserver;* hear, oh, hear!

Every element of the windy autumn landscape turns to living
form and animate activity. Nor does the rest of the poem ap-
preciably abate this same process of verbal sorcery.

Craftsmen in all times and places have pursued this practice
of artistic animism, whose chief procedure is the discovery of
analogies between the form of the objects to be decorated and
that of some denizen of the animate world. Just as the poet
clutches at every suggestion of similarity through which to
create metaphors by analogy with living things, so the Greek
decorative craftsman sought analogies between the shapes of
the inanimate objects on which he worked and those of animate
beings into whose likeness he could modify them. The legs"
of chairs become the legs and claws of beasts;[2] the stand of a
mirror becomes a human being; the shaft of a column becomes

a giant or a maiden with a basket on her head; a bracelet becomes a twisted snake; the "nose" of a lamp becomes the muzzle of a beast; the handles of a cauldron become two wrestlers leaning over at grips with each other. In other epochs, weather-vanes become cocks or fish; salt-cellars are ships or windmills (and therefore half-way animate, since they now can appear to move); nut-crackers are dwarves; andirons are beasts; door-knockers are demons; bellows are dragons; and so on without limit, but by no means without reason.

Just so in Egyptian art a spoon becomes a girl lying prone with outstreched arms holding a duck whose movable wings are covers for the bowl of the spoon. In medieval illuminations the initial letters of manuscripts suggested grotesque animal analogies to the embellishing copyist. In the Scythian art of the Russian steppes this animistic principle finds a characteristic and strange complication: the various parts of an animate representation are in their turn subjected to a similar scrutiny for possible analogies, as when the antlers of a deer become the long-necked heads of birds and the muscle-folds at the shoulders acquire beaks and eyes, or the wings of winged lions are decorated to the semblance of fish. In the Mayan art of Central America the very same practice obtains; each portion of a pictured person or object becomes a new field on which the artist can uncurb his imagination until the whole surface of a design is a puzzle-picture of ramifications into avian, reptilian, floral, and human motives.

Greek art did not permit itself these mixed metaphors until a late period. There was a sound esthetic practice which refrained from treating an animate representation as a field for further invention, since to do so would be to destroy the organic unity and animate value of the original design. The es-

thetic objection to Scythian and Mayan decoration is that it fails in the primary purpose of raising inanimate objects to an animate status. We can see how a quiver-cover might become deer or gryphon if we are ready to allow that inanimate matter may be informed to an organic structure; but we cannot understand how a wing can be a fish or a fish be a wing, because each has animate existence in its own right. For the same reason an animate representation cannot carry irrelevant decoration. Greek taste would not have countenanced the Vettersfelde fish, whose scaly body is adorned with animal motives in good early Ionic style, while his double tail curls up into rams' heads; nor would it have approved the Kul Oba gold deer, whose flanks are overlaid with image of gryphon, hare, lion, and dog. Yet both these objects were probably made by Greeks —for barbarian trade.

In the decorative arts, as we have seen, the representational subject-matter is suggested by the chance shape and appearance and purpose of the material to be decorated. In the "pure" arts, such as sculpture and painting when they are producing works which have no other use or purpose than their purely artistic and esthetic aim, the choice of subject-matter is not dependent on the invention of animate analogies. Yet theirs is the same underlying impulse of shaping the inert and merely material into the illusion of animate existence. I cannot therefore see much merit in the current distinction between "pure" and "applied" arts, between the work of art which exists in its own right merely for the artistic pleasures that it gives and the work made for a practical and utilitarian purpose but embellished with such artistic touches as may be conveniently and incidentally applied. This is the current conception in the popular mind; but of this distinction there comes but little good. Sooner

or later it leads to the impression that art is something external to material objects, something which may be added or omitted at will, like the interior furnishings of a house, and so occasions the idea of the Superfluousness of Things Esthetic—an idea which is only too commonly the popular attitude toward art nowadays. This idea still has a tenacious hold upon architecture and even upon professional architects, who are prone to act as though they thought that artistic effects were something accessory which were only added for the sake of good appearances.

In "pure" and "applied" art alike, we shall find among the Greeks this same process of animism, so that it should occasion little surprise that the subject-matter of Greek art is almost wholly confined to the world of men and animals and that the Greek artists showed little fondness for portraying inanimate nature. So strongly did they feel their province to be with the higher animate forms that they rethought the inanimate, wherever possible, into animate terms which could be substituted for it. This practice, which may be considered fundamental in their attitude toward art, necessitated a sort of symbolism in terms of animate objects. Thus, though a chevron or scroll may often typify water, the favorite method was to select some aquatic animal. The beast stands for its habitat. A crab at the foot of a boulder gives us the Saronic Gulf washing the base of the Scironian cliffs; on Greek coins of the classical period, dolphins stand for the sea, freshwater fish for rivers, a heron for marshland, a swan for a lake. At times the symbolism seems forced, as when a maid stands for a spring of virgin water, or a man-headed bull for a roaring stream; but that is because we today have dropped out an essential link in the chain and forgotten how the Greek mind peopled fountain,

tree, and hill, and river with local divinities—an instance of this same process of animizing natural phenomena by visualizing them in animal or human form.

Largely because of this process (but also because the Greek was little interested in showing in his art those objects whose typical form he could not clearly catch) Greek artists paid little attention to landscape. A large part of the delight of landscape-composition lies in the synthesis of intelligible but rather haphazard appearances into a design full of the illusion of spatial depth and into a color harmony full of the suggestion of lights and shadows; but of typical form there is little, and of human analogy there is none. A Greek mountain has only its skyline; the rest of it is a flat plane with haphazard splotches of rock, herbage, and tree. Each tree may have a characteristic shape when examined singly and close at hand; but at a distance, merged with others, it contributes vaguely to a whole which has no unity of structure or necessity of interior form. On the Arezzo amphora where Pelops carries Hippodameia on his chariot, the essential constituents of the landscape are timidly and disjointedly given; above, a lightly scratched profile typifies mountains against the sky (those marvellous mountains of the opposing shoreland that stand so gloriously across the blue Corinthian Gulf); by the chariot two isolated tree-forms suggest the olive-groves of the Achaean shoreland; in front, a wave pattern and a plunging dolphin symbolize the windy blue reach of sea. But there is no synthesis of a seen and solid landscape. The actual and complex scenic setting was apparently formless to the Greek mind: there was no way of drawing it, and there was no way of animizing it.

It may be remarked in passing that our discussion suggests that a scrutiny of Greek drawings and sculpture will throw no

light on that often-raised and rather fruitless question whether the ancients were sensitive to the beauties of Nature. From the striking absence of landscape scenes, whether of forest or cornland or olive groves or rocky shores or pine-covered heights, no conclusion may be drawn as to the sentiments of the ancient people who lived in that (still today) marvellously beautiful country-side.[3]

In Greek art Nature is rethought in terms of human or animal analogy. Greek coins are the *locus classicus* for a study of the workings of this process.

We of today are generally content to convey our meaning on our coins by engraving verbal information: "United States of America One Dime E Pluribus Unum Liberty 1957 In God We Trust." To this explicit announcement the "art" is fairly superfluous, something by way of ornament and cultural tradition. Any more or less frigid allegory will serve; a young woman with a Phrygian bonnet will visually embody the abstract concept Liberty, however little connection there may be apparent between idea and symbol. The Greek used more thought and was more conscious of his aim. He used non-representational matter such as letters and legend very sparingly and succeeded in imparting a surprising amount in purely visual terms. On the coins of the various ancient cities the geographical situation, the historical and mythical events of the past, often the very names of the towns and the value of the coin were all conveyed without a single written word.

Syracuse showed its spring of pure water on a small sea-girt island (the fountain Arethusa on Ortygia) as a young girl's head encircled by dolphins. The lake into which near Camarina a river widened before it reached the sea was shown by a nymph upon a floating swan surrounded by a scroll of little

waves, while on the other side of the coin a horned river-god with a sea-fish below him told the rest of the geography. At Selinus the story of Empedocles' success in draining the pestilential swamp was converted into terms of gods and bulls and marsh-birds and other simple visual apparatus. At Syracuse a four-drachma piece had a four-horse chariot, and two horses and a single horse indicated the two-drachma and the one-drachma pieces, while a wheel, as part of a chariot, was used for subdivisions of the drachma. There were no inscriptions stating the current values of these coins.

The frequent "punning" or "canting badges," such as the rose for Rhodes, the goat for Aegae, were due to the desire to set even so unvisual a thing as the name of the town into representational form.

In order to succeed in so thorough-going a conversion into visual terms, art obviously must have recourse to symbolism; and to this extent Greek art became symbolic, since its *representata* often stood for things other than themselves—as when a swan and nymph stand for a lake, a man-headed bull for a river, a marsh-bird for a marsh, or an object for its homonym (like Rhodes and the rose). But there was no mystic or mysterious intention and none of that deliberate obscurantism with which symbolism has so often allied itself. The symbolism of Greek coins was a kind of picture-writing; but it was not a hieratic script with an esoteric meaning for the initiate (as Christian iconography was at times), nor was there anything arbitrary and inevident in the relation between symbol and meaning, as tends to be the case when symbolism has literary or ritual associations. It was not in an effort to point at mysteries or to obscure the obvious with pretended subtleties, that Greek art had recourse to symbols.

The Greek taste insisted on a thorough fusion of intellectual and artistic content, so that neither should obtrude itself to the detriment of the other. The Arethusa heads on Syracusan coins owe nothing of their artistic excellence to an understanding of their reference to a sea-girt island; nor is the simple picture-language obscured by irrelevancies added to improve the design or increase the artistic appeal. This canon is markedly inapplicable to the arbitrary and conventional symbolism of medieval iconography, where not to be initiate in the meaning is often to miss the artistic intention. The Greek artist was evidently no mystic: knowing clearly what he was about, he merely strove to make his intention equally clear to others.

Having reduced the material content of his design to simple animate visual terms, the Greek coin-engraver further limited his range by making these terms conform to the material medium and to the shape and size of the field and background. Coin-stamping was a kind of relief sculpture in silver and gold, and no visual conception was applicable unless it was appropriate to such an art. A town near a lake is in itself a visible thing, which can be shown by drawing; but it was unfitting to those formal artistic demands which coin-design suggested to a Greek artist. The nymph and the swan were animate equivalents, sculptural subject-matter, amenable to spatial arrangement within a circle as a balanced pattern with ordered lines and surfaces. They had not merely an intellectualized meaning as symbolic of a god-held (and therefore man-beneighbored) lake, but an artistic import, in that they embodied artistic form and evoked artistic emotion. Heads, rather than full-length figures, became favorite coin designs, because the small size of the coin admitted sufficient detail for such a theme (but not

for a larger one) while the metal was especially fitted for those contrasts of smooth surfaces and chased areas which the subject occasioned. And, finally, there was an inherent harmony of shape between coin and head, combined with an effective contrast between the unvaried curve of the one and the changing profile-lines of the other. With us the presence of heads on coins is rather an empty tradition: with the Greeks it was a discovery of the inherent fitness of the theme to all the artistic requirements which could legitimately arise. It became canonized, because of its artistic rightness, in days when no mortal except the distant Persian king yet dared to put his own image on a coin to mark his own greatness and authority. It has survived for reasons of political and dynastic convenience rather than through any feeling for the singularly happy solution which it offers to a difficult artistic problem.

We have considered various impulses and interests which determined the choice of artistic subject-matter in Greek art. And it has been indicated that the artistic process did not consist wholly in servile imitation of seen appearances to the best of the workman's technical ability. On the contrary, the representational subject-matter is presented under the modifications imposed by artistic forms. Art has its own devices of harmonization of part to part, its own devices of spatial suggestion, its own devices for arousing and appealing to the esthetic sensibilities; and to the dictates and demands of these devices the representational subject-matter must conform. Our study passes therefore from the subject-matter of Greek Art to the Forms of its Artistic Presentation.

II

THE FORMS OF ARTISTIC PRESENTATION

AN OFTEN USED (but perhaps not over-used) analogy speaks of art as though it were a language. In place of sounds art uses seen appearances and arranges these according to its own syntax and grammar in order to convey its artistic meaning. The analogy is inexact because the sounds which we use as words are nothing in themselves, whereas the sights of art are imitations of independently existent objects. Nevertheless the comparison has the very great value of diverting the attention from the mere representational subject-matter of art and directing it toward non-representational form. As this is the initial step in esthetics which the general public is so loath and so slow to take, there is no better philosophical approach than this metaphor or comparison.

Under this analogy, the *representata* of art do service as the words of the language. The formal arrangment is the grammar and syntax. The esthetic emotion is the meaning. In order to impart this emotion, the artist puts *representata* in artistic form—very much as we put sounds which are words in co-

28

herent grammatical construction in order to impart intelligible information. Under the same analogy, just as we cannot make a sentence without syntax, we cannot make art without artistic form; and just as a sentence with correct grammar may yet have only an idle or empty meaning, so *representata* in artistic form may have only a trivial or empty emotional value. Accurate representation through painting or drawing, and accurate imitation through modeling, will not in themselves constitute art, any more than a random picking-up of correctly spelled and grammatically coherent words constitutes a use of language.

The representational subject-matter, molded to artistic forms, fuses its imitative content with their non-representational appeal; from this fusion results the material of our esthetic contemplation. The mind, trying to understand what it is that the eyes are conveying to it, is at the same time affected by the purely formal emotions of linear structure, pattern, balance, and a host of half-unclear suggestions and appeals; and all this emotional stimulation fuses with the recognition of the object represented. On the appropriateness or unappropriateness of the formal emotion depends the whole color and feeling of our recognition. Indeed, the fact that our recognition is more than a mere identifying and naming of the object, that it is an esthetic perception with a distant emotional coloring, seems to be due principally to two causes: (1) the knowledge that the represented object is an illusion, and not a real object which must be treated as we treat real objects in our real world, and (2) the fusion of representational illusion with something non-representational and yet emotionally appropriate to the representation in which it occurs.

Our argument is much in need of concrete illustration; and

for this purpose a very well-known statue from the opening years of the fifth century will serve admirably.

With so generous an admixture of Thorwaldsen's restorations in them, the pedimental figures from Aegina cannot be used without caution. But the kneeling archer with the lion's-head cap, the so-called Herakles, has suffered less than most of his comrades and is apparently original save for his right forearm and the lower part of his left leg. The pose and the outline are therefore assured, and Furtwaengler's investigations leave little doubt as to the angle from which he was intended to be seen. It can scarcely be accident that from this point of view, as from no other, the figure patternizes to an intensely formal presentation in which an almost diagrammatic indication of the mechanics of an archer drawing his bow dominates the pattern. In the shooting of an arrow two forces are prominent, the strain of the bow-string back-drawn and the impetus of the released arrow on its flight. The strain and the direction-of-flight are nearly at right angles to the body of the archer. To offset this strain, a bowman will communicate its thrust through some diagonal prop or pose of his legs. Were we to make a diagram of the mechanics of an archer drawing a bow, it would look almost like a diagrammatic simplification of the sculptured figure of Herakles. "Naturally" (one might say), "because if those are the actual mechanics of a man shooting a bow, the archer cannot help displaying them." But the truth of the matter is that he can very easily avoid displaying them, for the mechanical strain and counter-adjustment are within, and not along the surface line of his limbs and clothes. That the pose can be shown without right angles or supporting diagonals is patent from numerous drawings of bowmen which can be found in modern illustrations. But in the Aeginetan

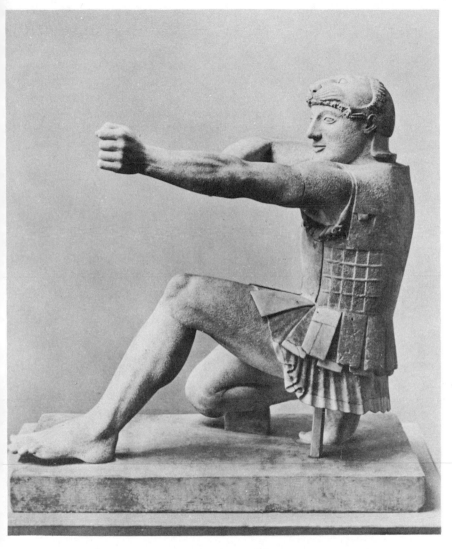

Herakles Bowman, from pediment of Aphaia Temple, island of Aegina
(now in Munich).

warrior every line that is not suggestive of these forces is rigorously altered or suppressed. Even the ornamentation of the jerkin is made of squares and right angles above and diagonal folds below, as though to force the eye into picking up that notion. Thanks to the lion's-head cap, even the head-form of Herakles is square. And what could better evoke the emotion of the straight, swift flight of an arrow when the string is loosed, than the long, forward stretch of arm with the flickering motion-line of its contours?

Of course the artistic intent is not to present a dynamic graph of the equilibrium of forces: art is not interested in the intellectual presentation of physico-mathematical information. The purpose of the device is to awaken in the spectator a sense that there are such forces at work, in order that what he sees may not be only a casual picture on his retina but may come to him as an apprehension of a thing muscularly alive and full of powerful forces. While we are recognizing the carved and colored marble as Herakles the Bowman, we are at the same time being affected by purely formal emotions; and this emotion fuses with our recognition to produce the whole emotional state of our artistic contemplation.

In the statue of Herakles the right angles in which the lines and masses meet do not in themselves represent anything, any more than a geometric theorem represents actual objects (however much actual objects may exemplify and embody geometric theorems). The right angles are a pure form: pure, because we are considering them apart from any material content or representational significance; form, because they are an abstract schema into which representational matter may be fitted, as the kneeling man is fitted into the abstract pattern of lines.

What is the emotional value of this abstract pattern? That

would be hard to say. It is possible to make a drawing of such an underlying pattern without suggesting the silhouette of a human figure, and any one may experiment on himself to see whether he derives any emotion from contemplating such a pattern (provided he is able to look at it without thinking of it as a picture of a kneeling man or any other recognizable object of the real world). My own experience is that I have no clear or definite emotion from such a test. If I were to assert that I derived feelings of solidity, maintenance of equilibrium amid disturbing forces, power, endurance, or any similar sensations, I should be quite dishonest with myself and be doing considerable violence to my real state of mind in forcing myself to believe that I was having any sort of definite, vivid, tangible emotion. But that I am affected (however unanalyzably, however vaguely, as though by a dream without characters or scene) I could honestly maintain; and as the lines and surfaces are changed and the pattern changes with them, I can appreciate that my affection alters *pari passu*. But it is only when this abstract play of lines and angles and surface-shapes appears incarnate in recognizable objects derived from the real world of my experience, that it seems to get sufficient emotional focus and bearing for me to appreciate clearly (or even describe) its character and range.

This is the reef on which non-representational sculpture and painting strikes and founders. In very recent times there have been attempts at a purely "dynamic" art in which we are asked to apprehend merely the emotion of surfaces, the clash of forces, the strife of line, the delights of linear motion, the appeal of contrasted and mingled colors. But no matter how we educate our sensibilities, we can never experience anything tan-

gible or definite out of these disembodied pure forms. The play cannot go on without characters. The spiritual kernel of a drama may be very abstract and lofty and vague and universal; but unless it embody itself in concrete human actors who speak intelligible words, those spiritual powers will never recreate themselves in the minds of an audience. Representational art is representational not by accident but because only so can it have its full effect. However, this effectiveness does not lie in the mere picture of objects from the real world, but in a successful fusion of this objective matter with the formal suggestions which are the province of the particular art.

Seldom is the reason for the appropriateness of a particular pattern to a given work of art so manifest as in the Herakles from Aegina. And yet most of us, if we are sensitive to the appeal of sculpture or painting, are aware and can feel (even though we cannot assign a reason for our impressions) whenever a pattern or play of line contributes to the emotion with which we contemplate an instance of those arts. In fact, it is a plausible theory that one essential distinction between esthetic and ordinary contemplation is the appreciation of abstract formal values in the field of vision and the fusion of these with the normal process of recognition of the objects, so that there results an emotional (instead of a merely pragmatic or practical) apprehension. If this is so—formal values being accidental in Nature and not generally looked for by the spectator, but deliberately chosen for their influence and appropriateness by the artist and introduced into his work—it should be obvious why esthetic contemplation may be emotionally so much more intense when it is directed toward a "copy of Nature" such as a work of painting or sculpture, than it is when in the presence

of Nature itself, from which all such art confessedly derives its material themes.

I have referred to the modernist suggestion that pure forms might be used abstractly without any representational content. It is worth a moment's attention, since it will have an ultimate bearing on our theory of Greek art.

In a certain London studio I was once shown an inlaid table-top whose geometric assortment and arrangement of planes and lines were intended to give me (so I was told) emotions of speed and power, of thwarted effort, and energy ready to burst forth. But I stood dully by and felt none of this intarsiate vitality rush over me. For it is not abstract speed and power that I can understand, but the speed of a railway train or the power of a goaded ox. Nor does the flying apart of six-inch lines give me a sense of flight except on a six-inch scale; but if I have the illusion that those lines are somehow (let us say) morsels of clod and bridge-rail, something of the sundering energy of a bursted shell comes vividly before my senses. The table-top was a demonstration in pure form. It was also a demonstration of the futility of such formal effects when they are not imma-nent in the illusion of sensuous objects, amid whose time and space we put ourselves with that strange sympathetic power which we employ whenever we see pictures in a mere square of painted cloth.

By considering the art of painting, it is still easier to estab-lish our argument concerning the artistic function of pure forms.

The most obvious and easily distinguishable pure forms which painting employs are line, mass, color relations, from which are occasioned motion, pattern, and rhythm, with their

accessories balance and thrust. I call these *pure* forms because they are independent of the subject-matter of the picture. They could exist whether the picture represented anything or not, and it is irrelevant to their existence whether the represented objects are rightly or wrongly drawn. They are pure forms, therefore, because they are not *representata* but *schemata* into which *representata* may be fitted. They are abstract in the same sense that geometric figures or kaleidoscopic designs are abstract, having for content no objects of the world of experience, governed not by fidelity to Nature, but formulable according to some intellectual requirement, expressible perhaps in mathematical terms.

How can line in an actual concrete painting be an abstract form? does it not always bound or enliven the objects represented? then where is the abstraction, where the irrelevance to the represented object?

True; but suppose that we isolate various lines by removing them from a picture and putting them by themselves. For lack of context, we have no notion of the objects which these lines helped to depict. We are treating them as unrepresentational lines, as lines that show nothing. Are they all emotionally alike? do we get the same feeling from every one? Not quite. We may be somewhat at a loss on being asked to derive emotions from them at all. The performance is artificial and savors of the supersensitive behavior of the avowed esthete. But I do not suggest glutting a healthy appetite on a morning rose, nor pretend that the contemplation of a page covered with lines of varying curvature should yield any profound emotional state. My theorem is quite simple and rather banal. A straight line looks stiff; certain curves appeal to us as graceful; wavy lines have a restless effect; and more complex lines compound more

complicated phenomena of the same general sort. That is all that I mean by emotions derived from contemplating lines— very vague, rather undefinable impressions. Whether they are suggestions borrowed from familiar objects which show that particular line, or reactions due to an instinctive appeal to our gravitational and muscular sense, or products of our intellectual appreciation of the relations of the various component portions of these lines, is a matter of psychological inquiry which is irrelevant here and of no particular importance for the contention. If to this vague and feeble degree we are prepared to say that lines are not emotionally alike, no matter whether we can define or clearly distinguish our feelings about them, if we are ready to say that not merely do the lines differ one from another, but that we differ when we look at one line and another, however slight and however trivial we judge this difference to be—then I have established the purely formal character of lines.

But lines may also be representational. Such and such a combination of lines depicts such and such an object—a tree, a fish, a frog, the Virgin Mary. Does a line lose its formal value, the moment we see that it represents a real object to us? Just here is the fundament and base of the contention. From the fusion of the two aspects of a line—its purely formal value with its representational quality—arises a new thing which I call the esthetic or artistic emotion. This new thing, which may be surprisingly intense and vivid, *is not discoverable either in the represented object* per se *or in the mere formal value of the lines used.* It is a product of the fusion, often as unexpected and as novel as a chemical reaction. I admit the miracle, but I plead the fact. It is no more remarkable than the extreme intensification of emotion attendant upon the fusion of language

with the recurrent beat of metrical rhythm on which poetry draws so lavishly.

The forms of art, considered in and for themselves, are nearly always trivial and irrelevant. The esthetician, knowing this, never judges them thus for what they are, but for what they can do. Surely we might hold that the jingling of words of similar ending and the constant ordering of words into alternatingly accented and unaccented syllables is a puerile pastime for a grown man; but if we proceed to rule them out of poetry on that ground, we shall soon find out where we stand —or some of the modern formless poets will soon instruct us.

There is another formal function which line may perform— that of suggesting motion. The eye has a tendency to follow lines and to travel with greater or less ease according to the kind of line. It would be childish to claim that any very extensive spiritual experience is derived from thus travelling around on the lines of a picture. If we concentrate on the purely formal element, the result is extremely trivial. But if all these effects of acceleration and retardation, continuity and disconnection, intricate volution and open sweeping progress be encountered and scarce-consciously performed during our contemplation of the objects presented by the picture, the triviality vanishes. The things in the picture take to themselves the emotional qualities which are latent in the pure forms. Swiftness to our eye in travelling over lines is indeed great swiftness when those lines, measurable in inches, appear to us as wide uplands stretching to remote hills. And when difficult progress over broken lines, around uncomfortable angles, and through perplexing interlacings, is performed along what we accept for beams and joists and stays of a vast dungeon-room, our whole being seems confined and shut in, because we have transferred our ocular

perplexity and fatigue to our imagined corporeal existence amid the presented scene.[1]

But (it will be said) if each of the lines which depict a given object has its particular formal value, the resulting emotion depends on the particular shape of the object and not on the artist. That is true, to a certain extent. It is difficult to alter the emotional value of the lines of a very stout woman or an Ionic capital. But the objection will quickly be seen to be superficial. There are numberless angles from which an object can be drawn, and hence numberless modifications of the necessary lines; interior lines can be modified almost at pleasure; the relations of the object to the lines and surfaces of the rest of the picture are at the artist's discretion; and, finally, the object can be "misdrawn" so as to give it lines which would not actually occur in the photographically correct delineation. To what extent is this artistic "misdrawing" allowable? That is scarcely the esthetician's affair; but I am inclined to think that the only limit which can be demanded is the limit beyond which the spectator ceases to recognize what the represented object is intended to be. But artistic taste will nearly always assign a limit much closer to the photographically correct.

Extreme painters—the Outragists, if I may so dub them— often depart very widely from Nature. I must confess that to me distortions and malformations of decent human anatomy invariably introduce a strong element of displeasure and a revulsion away from all sympathetic contemplation, so that my final emotion is strongly modified by these unfavorable elements. Now it is a matter of experience that wherever dislike and repulsion are markedly present as components, the resultant esthetic emotion is not likely to be of much value. (There must be a fascination in ugliness before it can successfully

heighten our artistic emotion.) Our friends the Outragists would have us concentrate purely on formal considerations and forget the unpleasant modifications insofar as they touch the real world. We are not to think how we should scream if we encountered in the open a woman with cubical hips and a mouth curling vaguely beneath one ear. "Forget all such reflections," they might bid us; "this is not Nature, but Art. These lines and surfaces are expressive, significant. They introduce the potency of abstract values conceived by the artist and undiscoverable by the anatomist or the photographer. Something new has been created, a new and more primal emotion. To that lay yourself open."

A new emotion, truly; but of what sort? Into the fusion of pure form with represented object there enters a host of component elements. The represented object which here goes into the crucible is not just woman in general, but this particular woman with the bodily characteristics with which she is depicted, and along with these go all our associations, our attractions and repulsions, our memories and imaginations that are awakened by the sight of this woman as she is presented to our sight. There is no way of keeping these out of the crucible; for art is not an intellectual or geometric abstraction from ordinary experience, but a transformation of our own sensuous world with all its illimitably complex ramifications of feelings, pleasures, desires, fears, superstitions, instincts, memories, associations. All these go into the crucible. And if the brew be full of unpleasant and distasteful humors, so that the final draught is bitter and puckers the lips, it is idle for the artist to bid us concentrate our palate on some one flavor and ignore all the rest.

As long as the resulting emotion depends on a fusion of

form and matter (and it is my contention that this is the case) we must be prepared to recognize that the "new emotion" is an emotion about an old world with which we are irrevocably allied for our delights and our dislikes; and as long as we suggest that world by representing its objects, we must be prepared for all the worldly suggestions that such representation entails. We can "misdraw" as much as we like—only, we must be prepared to accept the consequences.

If we make this reply to the initiate modernist, he will tell us that we ignore the special intention by being insensitive to the formal values. If we ask him then, "Suppose that, in order to introduce certain formal values, the object came to be represented like (forgive the levity) an elephantiac scrub-woman recovering from a railway accident, do you hold that these formal values are arising around Woman-As-Such or around that particular distressing specimen of her sex?" From this point the discussion should become more entertaining. For our contention must be that either the fact that a woman is represented is irrelevant (in which case, why a woman at all? why not pure pattern?) or else this particular woman, just as she appears in all her discouraging deformity, is an integral part of the emotion. For that a painter can introduce "woman in general" into his painting and draw her or misdraw her as he likes without affecting her "womanliness" or our conception thereof, I entirely refuse to allow. The extremist idea seems to be that so long as we recognize what the object is intended for—a house, a tree, a human being—the formal values will fuse with our general concept of house, tree, and human being, as though the whole process went on in a region of abstract thought instead of amid our immediate vision of particular objects every detail of which was effective.

Pure form to the detriment of representational fidelity, or representational fidelity to the detriment of pure form—both are esthetically mistaken; for both tend to suppress an essential factor of the artistic appeal.

I have insisted that there must be a sufficient measure of representational illusion; but it is also equally clear that thorough-going representational accuracy, because it tends to eliminate the artistic form, cannot be a criterion of artistic achievement. In representational art actual sensuous deception is rarely intended. By imitation, the appearances of the real world are shown in artistic form; but it is not art's desire to have that imitative presentation actually mistaken for objective reality. Of this we can readily convince ourselves by examining the various devices of spatial presentation which the arts employ. Often we shall find that the presentation is one-dimensional in its emphasis insofar as there is an insistence on the *linear* aspect, with a consequent suppression of the more solid and extensive spatial qualities. Of this class are many of the Greek vase-designs, especially during the Early Red-Figure period; and one essential element of Greek low-relief is this insistence upon linear presentation. In other artistic products the presentation is two-dimensional in its emphasis, in that there is an insistence upon the *surfaces* which the objects of esthetic contemplation occupy in the field of vision, with a consequent diminution of the illusion of solid spatial existence. Of this class are certain vase-designs, much relief-carving, and (presumably) most of the earlier wall-paintings. Here too we shall have to classify the essential element in the esthetic appeal of Greek architecture. Finally, there is three-dimensional presentation, the cardinal problem of sculpture-in-the-round and one

of the great preoccupations of architecture (though not in classical Greece) and of painting (in certain very developed periods of its career). Since successful three-dimensional presentation occasions a very vivid impression of completely objective existence in space, and since three-dimensional presentation alone can achieve this, it is only in the arts which aim at such presentation that imitative illusion ever threatens to be complete and to become delusion. Against such a fatality sculpture usually guards itself by an insistence on its material medium and the constant discrepancy between what actually is and what by imitation appears to be. Painting averts a similar mischance by creating its own luminous environment in which its imitations are kept within a spatial construction of its own, which will not fuse and therefore cannot be confused with the objective space in which the beholder stands. Architecture, content to imitate conventional objects of its own choosing, has no need to seek to avoid the appearance of solid reality for its creations, but on the contrary strives to present them in their spatial actuality with all vividness and a heightening insistence, achieving for itself the distinction of a fourth and unique genus of spatial presentation, the presentation of solids enclosing space.

It is to these devices of spatial presentation to which particularly this study will turn, rather than to the more familiar and well-understood formal devices such as composition, balance, "mass," "tonality," rhythm, and the other commonplaces of ordinary artistic appreciation.

In early fifth century Greek vase-designs the representational subject-matter is presented seemingly without desire to impart any illusion of spatial depth or solid existence in space. The

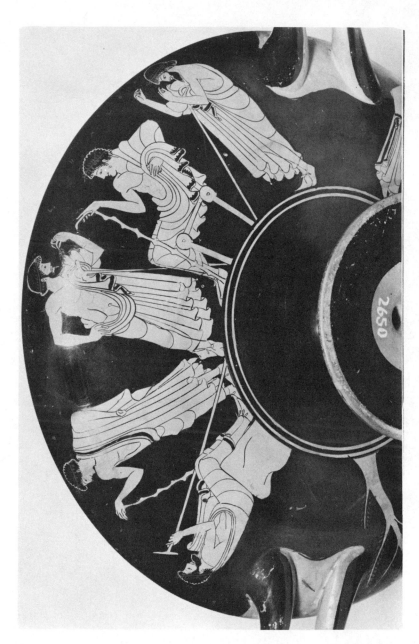

Red-figure linear design, from a kylix in Munich, attributed to the "Foundry Painter,"

draughtsmen of the early red-figure period confined their attention to discovering linear equivalents for the objects which they purposed to draw. The gods and heroes, athletes and revellers, whom they present to our sight, exist mainly by virtue of the encompassing lines which mark them off from their background. Internal lines are used for details of muscular grooving and drapery folds; but these lines are not used to create plastic illusion, they do not model or occasion any apparent spatial protrusion or recession, toward or away from the eye. The world of real objects is reduced to terms of linear appearances, and other spatial qualities have evaporated or disappeared. With their disappearance a subtle and barely describable change attaches to our impressions of the world in which these figures move—the world of these legendary people and athletes and revellers to whom we somehow allow existence as though they were real and alive, and yet whom we never mistake for flesh and blood. In our impressions of them we scarcely admit that they have the weight which belongs to solid material objects, nor that they must exert effort in order to move themselves. We ascribe to them a life of extraordinarily heightened animation and know somehow that the impulse of movement rules and runs through them, holding ankle and knee and hip and shoulder and arm together in one control. These are perhaps but vague and partial descriptions of what we feel; yet they will serve to suggest that the presentation of a human body wholly through linear equivalents—what I should like to call a presentation with one-dimensional emphasis—carries with it a power of peculiar suggestion and that this power is one of the specific esthetic resources of any art which chooses to employ such means of presentation.

As long as we are foolish enough to believe that realistic

illusion is the end and aim of art, we shall be wholly unable to do justice to the intentions of such an art's more purely linear methods. But if we are prepared to see in esthetic phenomena a fusion of objective representation with artistic forms capable of transmuting (even to the point almost of destroying) the sense of objective reality in the interest of artistic emotion, we shall have little difficulty in understanding the devices of Greek vase-design.

For example, we shall readily appreciate that it was not so much because the pigment dried rapidly (as is frequently asserted) that the ancient vase-drawings show outlines which must have been drawn quickly, continuously, and without hesitation, but, rather, because the whole objective existence of the portrayed figure and all those impressions of which we have just spoken depended on these lines. An interrupted contour, an incoherency of linear connection, would lessen the power of these impressions and work against the very purposes for which linear presentations were employed. The eye must be made to follow the run of contours and inner lines, so that the mind may never rest in the illusion that the pictured figures actually fill and occupy the space in which they are shown. And further, all suggestions of motion and those impressions consequent on the travel of the eye along lines, depend for their vividness on the clarity and insistence with which the linear exceeds any other spatial emphasis.

On the white-ground Attic lekythi later in the fifth century, although the method of presentation is still very linear, there is introduced the practice of making solid areas of color and of using these to build up area-relations in the field of the design. There is still no illusion of spatial depth; but the objective world is now no longer conjured up solely through linear

equivalents. The eye, instead of moving continually under the incitement and to the lead of lines, now rests on the full areas of color. In fact, the pictured objects of this world are presented largely in two-dimensional guise and with two-dimensional emphasis: they exist surely as surfaces, though still very precariously and uncertainly as solids in space.

Two-dimensional presentation very generally avails itself of the device called pattern. This device is so familiar that it scarcely needs elucidation. The textile arts, the arts of decorative metal-work, in fact all arts whose representations are conventional and ornamental rather than directly illusionary, count much on pattern. Even relief-sculpture and painting admit it as one of their major pure forms.

Now, what pattern is and why it appeals to us, I hope that I shall not be called upon to discover. For one thing, it depends upon symmetry of parts, a correspondence of right with left or upper with lower. A kaleidoscope cannot fail to produce patterns; for however orderless and crazily the central colored sherds lie, the mirrors will so echo these elements by reflection and inversion that order and balance will be built up on disorder and there will be pattern. And in apprehending pattern there is both the simple joy of recognition (when we detect repetitions and inversions of the same theme) and the intellectual joy of discovering spatial relationships and the generative principles of construction. But there must be some deeper appeal than this, for the sense for pattern seems to be more primitive and to lie deeper than such sophistications and the joy in it seems to be strangely clean and satisfying. Intellectually we may feel contemptuous of the triviality and practical irrelevance of its behavior. Yet something in the contemplation of pattern goes as deep as our instinct against bodily de-

formity and approval of fully and evenly developed things, whether they be flowers or children or our lovers' bodies. (Is it then to be wondered at if pattern is insistently present among the artistic forms of a people so addicted to athletic training and the sight of the nude as were the Greeks?)

Whatever this sense of pleasure and approval may be in itself, it is carried over to the represented objects of art when these objects are visually grasped as inherent components of a patterned design. Furthermore pattern unifies the objects to which it is applied and gives a consequent sense of internal cohesion, so that scattered elements of a landscape or discrete human beings of a sculptural group may impart, merely because of the pattern in which they are put, a sense of relevancy and fitness to appear together. We are aware of a unity which we may take for the all-penetrating unity of Nature or the unifying force of an artist's creative idea, though it arise merely from the unity of the unmeaning pattern in which the trees and fields and hilltops of a painting are shown.

What art may do with a pure form, with pattern void of representation, may be well studied in Mohammedan art. The religious ban on imitating and reproducing the appearances of living things turned the craftsmen of Islam toward a half-mystical, highly geometric, and thoroughly interesting pursuit of the decorative possibilities of pattern. Rugs and carpets, whose ornamentation is an Oriental tradition (our western methods of presentation went into the picture-world of tapestries) show a similarly high developed art based on the pure form, pattern. Birds and trees and flowers enter in, but scarcely for their own sake. They are usually patternized in appearance, with no pictorial space-relationship to one another or other setting than their appropriate position within the pattern.

Form has the upper hand, representation is incidental. Such work, whatever other artistic value it may have, seems to miss the spiritual opportunities of more representational design, because it does nothing with every-day human experience. It can appeal to certain deep-seated likes and pleasures and instincts; but it does nothing with them, it does not humanize them, it does not bring them to bear upon that world of sensuous life in which our spiritual experience is rooted.

It would be possible to classify the Greek use of artistic pattern under the captions Decorative, Unifying, and Suggestive. Decorative patterns would be those in which the pattern contributes merely the pleasures attendant upon its orderliness and loveliness of arrangement.Unifying patterns would be those in which the synthesizing power of the pattern is transferred and applied to the represented objects. Suggestive patterns would be those in which the geometric construction of the pattern conveys some suggestion of equilibrium, conflicting forces, or other mechanical effect. This last use is the most common during the latter half of the fifth century and is conspicuous in the metope compositions of the great Doric temples of that period. The Lapith-and-Centaur metopes of the Parthenon are generally composed about a central polygon of uniformly colored background; the enclosing sides of these polygons are the bodies of the two contestants; a very brief analysis shows that pattern is here functioning in all three of the aspects just mentioned, and that truth to Nature, spatial, and all other illusions are vigorously subordinated and dis torted in the interest of these three aspects of pattern. In consequence these metopes have been generally criticized adversely. I know of no critic or writer who has appreciated them for what they really are and for what they manifestly try to be

—two-figure compositions presenting intense physical strain of bodily contest wholly through the artistic forms of line, surface, and pattern. They were to be seen at a considerable distance and at a height of at least forty-five feet above the ground—in a position, consequently, where simplifications of line and pattern would be effective and minor fidelities to representational truth would be inconsequent.

Familiar as pattern is, artists and estheticians seem seldom aware that it is wholly a two-dimensional form and that therefore its occurrence in three-dimensional presentation is a matter of very unusual interest and importance. In a painted scene there is intentionally the illusion of depth: we construct a space in which the objects occupy positions at various imagined distances from the eye. Insofar as we accept this space as actual, no pattern is possible; we only apprehend the pattern by reducing all the objects to that which they really are—flat surfaces of color lying in a single plane. One peculiar effect of pattern in such a painted scene, therefore, is the demand which it makes on us to apply a two-dimensional arrangement of colored areas to a three-dimensional spatial construction and (impossible as it may sound) recognize that this space without depth and the space with depth are somehow fused, somehow one and the same. It should follow that, the more insistence there is on pattern, the less actuality we ascribe to our construction of a three-dimensional space in which the objects stand; and this might be carried to such a degree that we should be so dominated by the sense of pattern as to be wholly unable to make a three-dimensional construction at all.

I hazard the conjecture that this was actually the case with Greek wall-painting during the fifth century because the emphasis was almost entirely on the two-dimensional devices of

areal composition (pattern, balance, repetition of similar shapes) and on the one-dimensional devices of linear presentation.[2] But of the actual effect of Greek wall-paintings we know so little that it will be wiser to confine the discussion to a kindred art whose products are abundantly preserved to us.

Carved relief in Greece, notoriously, is subject to a seemingly arbitrary convention of execution in planes. Instead of a uniform abbreviation of depth (according to which, although two or three inches of projection may have to do duty for the entire depth of a represented scene, this projection will be correctly distributed *pro rata,* and every element will get its proper share) in the Greek convention of planes there is a very uneven distribution of depth. A human torso will be carved as an almost flat surface with undercut outline; and in general all the depth will be concentrated at the contours, within whose boundary all will be treated practically as a continuous plane-surface. A succession of planes, each stepped back at its edges to the next plane, will make up the entire relief. Of this series of planes, two will be much more prominent than the rest: the front plane, which results from the original smoothed surface of the marble slab on which the entire design was sketched before carving commenced, and the rear plane, which is the uniformly colored (but not necessarily uniformly distant) background against which the figures appear.

The origin of this convention is well known. Relief originated in Greece in the practice of cutting the background from a drawn or painted figure, leaving a flat drawing raised above a flat background. Where elements in the drawing overlapped or were intended to be at different distances from the eye, the farther element was set back from the hither one by the same device of cutting it back a stage. Out of this practice there arose

quite naturally the convention of composition in successive planes.

To have understood the origin of this convention is a very different thing from comprehending its artistic validity once it was established. If the Greek sculptors adhered to this convention throughout the fifth century, it is only fair to assume that they did so because they found it artistically useful and not because they were unable to hit upon any different method.

The frieze of the Parthenon presents the Panathenaic festival so divested of all scenic setting and of all recognizable spatial surroundings that archaeologists have raised the question whether it shows the actual procession, or some sort of rehearsal, or alludes to games and contests incident to the occasion. Riders and chariots, elders and musicians afoot, youths with animals, maidens with sacrificial vessels, all move as though on a narrow shelf seen sharp against the sky. The horsemen are often three figures deep, their arrangement even demands that they should be interpreted as riding six and seven abreast; yet space has somehow lost its density, and we fail to see them in the space which we know they must occupy. There is an abstraction of all else, and an insistence on our sense for harmonious and effortless motion, which gives to the contemplation of the frieze a quality of delight such as no actual spectacle may give. The esthetic explanation is apparent. Thanks to the convention of planes, the presentation is largely two-dimensional. Depth is a half-unreal assumption, and of it we have only as much as will satisfy the requirement of making motion in space a possible inference. Thanks to the convention of planes, we are forced to rely upon the contours to give these figures spatial existence; and so we are enthralled in the illusions of linear presentation. But also because of the convention

of planes, the pure forms of two-dimensional presentation are given free rein. In the cavalcade the set recurrence of horses' heads and riders' heads at the top of the frieze, the smooth areas of the horses' bodies at mid-height of the frieze, the rapid beat of recurrent horses' legs at the bottom of the frieze, can affect us with their spaced rhythms to an extent which would be impossible with a stricter illusion of depth. For, as we have seen, all these devices of pattern exist only insofar as we are able to reduce the presented objects to areas on a single surface.

Until the last quarter of the fifth century (the frieze from Bassae is one of the earliest instances to the contrary) the men and animals on a Greek relief, if they seem to move, always suggest motion in the plane of the background and not toward or away from the eye. This was largely a result of the frontal presentation which early drawing naturally employs; but it had its artistic justification because the plane of the background is the only direction which does not demand the construction of additional spatial depth (since if there is to be motion we must necessarily imagine a space in which it can take place). But additional spatial depth will further the three-dimensional illusion and thereby obscure the effects incident to surface and line.

The convention of planes and the convention of motion in the plane of the background are therefore artistic devices which are involved in the problem of two-dimensional presentation; their presence and meaning in the developed art of the fifth century cannot be adequately explained in any other way.

With sculpture in the round we at last reach the problem of three-dimensional presentation, with all its attendant intricacies and difficulties.

Not only is the question of three-dimensional presentation itself a difficult one; but the sculptural appeal is rendered extremely complex and confusing for the esthetician because, just as the arts which emphasize two-dimensional presentation generally include also the devices of one-dimensional emphasis (as when carved relief employs linear effects) so an art whose characteristic method of presentation is three-dimensional will impress both one- and two-dimensional presentations into its service. Since sculpture uses both the pattern designs of areas and the linear suggestions of contours and interior lines, there results for the sculptural appeal a fusion of many diverse factors and a consequent complexity such as does not characterize the arts which we have thus far considered.

As a memorable instance of this synthesis of many factors the major relief on the so-called Ludovisi Throne,—popularly (though mistakenly) identified as a representation of Aphrodite rising from the sea,—shows an astonishing combination of all three forms of spatial presentation. By the compositional pattern, attention is concentrated on the axial figure; by linear suggestion of streaming verticals and suspended catenaries, the central figure is made to hang poised in effortless equilibrium; by progressive heightening of the relief from the sides toward the center and from the lower register upward, the nexus of heads and interlocking arms imparts an impression of corporeal actuality surrounded by a sort of penumbra of unsubstantiality. It would be difficult to point to a more convincing example of the elevation of an uninteresting subject through formal transformation into an emotionally moving work of art.

In this extraordinary effect of a fusion of corporeal solidity with utter unsubstantiality sculpture has a unique opportunity.

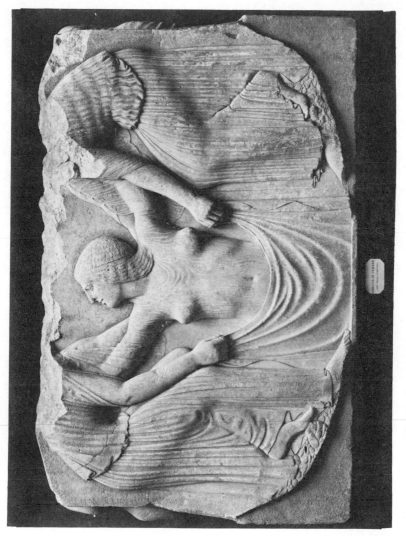

The "Ludovisi Throne." Rome. National Museum. Photo Anderson.

Most easily accentuated in relief-work, it yet may exert a strong influence in sculpture in the round, so that coincident with a three-dimensional presentation there may be the eerie negation of all the solidity with which the eye is so directly and so insistently affected. From linear presentation almost all the sense of motion in a statue is derived (though in a more Cyclopean way it can be suggested by surfaces, as in the Torso Belvedere). On relation of surfaces depends much of the appeal to the mechanical sense, the sense for equilibrium and control of bodily movement. In order to be truly effective, both this linear and this areal presentation must be embodied in a three-dimensional presentation, whereupon the influences of these formal devices will be ascribed (illusorily) to an actual spatial existent to which they will impart their peculiar emotional suggestions. It is in this fusion of one-, two-, and three-dimensional presentations that the real subtlety of the sculptor's art resides. But because of the complexity of the result, the esthetic analysis of the sculptural appeal has remained to this day largely unguessed and unwritten.

It is indeed scarcely surprising that, while the esthetics of the arts of one- and two-dimensional presentations are comparatively well understood and correctly studied, the arts of three-dimensional presentation have kept their secrets to themselves, so that sculpture has usually been considered with the utmost *naïveté* and architecture has seemed a simple, open and unelusive art—whereas, in reality, because it combines with its own specific device of presentation (solids enclosing space) the peculiar appeals of nearly all the other arts, it affords esthetic phenomena so complex in their combinations as to bewilder and wholly mislead the esthetician.

Accordingly, it will perhaps be excused as a not entirely dis-

proportionate emphasis if the remainder of this study be de-
voted to a consideration of these two, esthetically the most
highly complex of the arts, and to a scrutiny in considerable
detail of the attainments and devices of Greek sculpture and
architecture.

III

THE ESTHETICS OF GREEK

SCULPTURE

THE CARDINAL ESTHETIC PROBLEM in the analysis of the sculptural appeal is the determination of the way in which statuary works on our sense for spatial construction. We incline to view wax-works merely as artificial human beings that might be flesh and blood if they did not happen to be wax. The aim is delusion; and, beside the patent fact of immobility, the only material difference between original and imitation is the difference of material. We do not so see sculpture when we view it as a work of art. In order that we shall not so see it (as a realistic illusion) the art is careful to omit one of the essential marks of the real world—its color. Early Greek stone carving did not do this: it colored brilliantly, but conventionally. During the succeeding periods the lavish use of color may have gone gradually out of fashion. Certainly, the Hellenic bent for representations of the nude tended to keep the polychromatic influence subsidiary, and though the nude parts were somewhat altered in tint by the process which the Greeks called *ganosis,* this seemingly did not produce an actual illu-

sion of human flesh; while in bronze there obviously could be no intention of illusionary coloring (in spite of a few casual anecdotes of instances to the contrary).

Gothic sculpture was in general highly colored. The Renaissance (perhaps through the error of attributing a complete absence of color to the surviving ancient marbles from whose surface time may merely have removed all traces of the tints) accepted a colorless convention almost without opposition. From that time on, the tradition of unstained marble has maintained an almost unquestioned ascendancy. Today it is to be justified not as an accidental historical heritage, but on purely practical esthetic grounds, since it destroys the outright illusion and thereby facilitates the peculiar power of sculpture to work on us through spatial forms of its own devising.

In particular, the blank unorbed eye, by which the modern sculptor so readily makes us accept his carven men and women as purely ideal equivalents for flesh and blood, was a device seemingly unknown in Greek times. Since the ancient sculptors normally indicated the iris and pupil by applying color instead of by carving (because these are not plastic but purely chromatic shapes), the Renaissance believed that Greek marble statuary was made with blankly empty eyes. But to have thus omitted so conspicuous an anatomical feature would have flagrantly offended against the striving toward mimetic truth which, as we shall see, never failed to exert a dominating influence on the successive generations of sculptors.

In the archaic period there was no question of using color to produce a material illusion. Where the hair of the head and the beard could be painted blue or clear bright red, we need scarcely raise the question of the ulterior purpose of such decoration. In the early Hellenistic Age, when the Alexander

Sarcophagus was made, the realistic illusion was much heightened; yet, even then, the tones seem to have been so clear and pure that we may doubt whether anything but a very modified illusion of real appearances was intended. In view of the realistic attainments of the period, it is not safe to insist upon this point. More certainly, coloring was still half conventional in the period of Pheidias; but we are told on good authority that Praxiteles paid considerable attention to this aspect of the art, so that we may assume a more naturalistic tendency to have set in during the fourth century.

It would seem that insofar as the true colors of the real world were applied to Greek statuary the effectiveness of its formal qualities was not heightened but diminished. This would be a correct deduction were it not for the fact that a judicious use of color can enhance all those formal effects which depend upon the comparison and correlation of surfaces and areas (such effects as those of pattern and balance of masses), as well as emphasize outlines by contrasting the color of adjacent areas. If the color-scheme be kept conventional, these advantages may be turned to account without the disadvantages attendant upon illusionary color; and such a practice must have obtained in Greece before the conventional coloring inherited from the archaic period had been entirely abandoned, that is to say, in all probability, during the whole of the fifth and the first part of the fourth centuries B.C.

To return to an earlier part of the argument, the cardinal esthetic problem is the determination of the way in which the sculptural appeal works with our sense for spatial construction. The sculptor's aim is to present to us a cubic solid in such a manner that we can intimately appreciate its existence as a three-dimensional object. He must enable us to apprehend

the solidity of solids directly by mere ocular contemplation.

Ordinarily we employ a sort of intellectual construction toward the seen world. From the various appearances of objects from varying points of view we infer their cubic shape and position in space. We read off the meaning of foreshortening and perspective, and so get at an understanding of the solidity of objects not directly, but at second-hand. But in the apprehension of the sculptured form we get a more complete and a more direct visual comprehension of the solid object as solid. We do not see all around it (that clearly is a geometric impossibility) and yet we are intimately aware of its further boundaries (which are the surfaces on the invisible sides).

The real difficulty in spatial apprehension lies in the fact that a three-dimensional world is presented to our eyesight in two-dimensional form and we have to derive the missing dimension out of such data. The dimension in depth away from the eye is obviously the difficult one, and it is part of the sculptor's business to construct this for us so that we can apprehend it without mistake or trouble. How can he do this? By removing as much as possible from the difficult dimension and showing it in the two easy ones. By loading the two dimensions, he lightens the third. In practice, this amounts to the employment of three very definite devices: (1) intelligible pose, (2) planes of composition, (3) "modelling" lines.

(1) By intelligible pose I mean simply that the model must be presented in such a position that the beholder can clearly and fully understand what it is that he sees. This seemingly simple demand causes the greatest possible amount of trouble, just because there are as many aspects of a statue as there are points of view from which the beholder can look at it. In the

case of a free-standing statue in the round, it is apparent that theoretically there are as many points of view as there are points on the circumference of a circle, and that is an infinite number. Practically, the spectator will not demand complete intelligibility from more than a very few standpoints, and may usually deem himself fortunate if he can find any which are wholly satisfactory. Even with these limitations, it must be remembered that it is one and the same cubic form which determines all these more or less planilinear appearances (just as a hundred different photographs can be taken of a single solid) and a change occasioned in order to improve one aspect will introduce a relative change into all the other aspects. Yet we begin by demanding that from every viewpoint the pose should be intelligible, so that the whole construction of the represented object as a solid in space may be read off from any one of this series of restricted and quasi two-dimensional appearances.

More concretely, we may demand that no foreshortening should take place if it is not immediately intelligible as a foreshortening, so that we may apprehend the actual depth of the element which appears abbreviated.

In order to meet this demand the sculptor may try to make the silhouette always so characteristic of the bodily parts which it outlines that the mere contours will make them intelligible.[1] In this way he will be crowding as much representational significance as possible into the two visible dimensions and leaving as little as possible to the invisible dimension. The device depends for its success upon the sculptor's ability to draw an expressive contour and upon his sensibility to linear equivalents with which to conjure up an objective illusion.

The tradition of the expressive contour grew up and ma-

tured very naturally among the Greek sculptors. Primitive art draws very largely in profile, since the profile view is the most readily intelligible and the most vividly retained by the visual memory. In draughtsmanship, foreshortening is a difficult accomplishment because the outlines which it demands are not those which the mind insists upon retaining as characteristic. Sixth century vase-designs are all based on profile appearances. This was also true of early relief, because the artist proceeded from a drawing sketched upon a smooth surface of stone and chipped away the background around this design. More surprisingly, even sculpture in the round is subject to similar influences. The sculptor strove to embody the human form as he visualized it. In the case of marble statuary he may have drawn a flat image on the face of the stone and then hewn inward for the third dimension until he had given his sketch a solid embodiment. The early statues are thus calculated from a single position, from immediately in front. Their depth was apparently controlled from points at right angles, that is squarely from the right and left flanks of the statue. In consequence of such a procedure, the statue was evidently fashioned for the four cardinal viewpoints (front, back, right, left) and from each of these it displayed the characteristic silhouette which our visual memory especially retains.

The Man with the Calf (mid-sixth century Attic) is an admirable example of a frontly composed statue. Seen from in front, it exhibits a pattern of line and surface such as a drawing or flat relief might show. As we move around the stone, this pattern gradually folds up and vanishes, and no satisfactory viewpoint occurs until we come squarely on the flank, when a secondary but not wholly intelligible composition arises, with profiles of the heads of the calf and its carrier.

So marked is this frontality and so striking is its two-dimensional pattern, that when we stand squarely in front it is almost impossible to see the statue as a solid. It seems flat, in one plane. In the terms of our previous discussion, the third dimension has been so drained of its content and the other two dimensions have been so filled, that under the influence of the plane-making pattern there is nothing to give the illusion of depth. The process has in fact been carried too far. The contour has been made so intelligible and the frontal plane has been so emphasized that the dimension of depth has no necessary function or obvious existence.

Such frontal composition has the patent advantage of insuring an expressive contour—but not for all viewpoints. How a harmonious succession of expressive contours can be combined into a single solid, so that from every point of view the statue may be immediately intelligible, thus comes to be a cardinal artistic problem connected with sculptural pose. The Greeks solved it gradually. A century after the Man with the Calf, Polykleitos has not yet found the full solution. His formula (as embodied in the Doryphoros and the Diadumenos) shows only a frontal solution. The rigid median line now bends in a long, gentle curve and counter-curve from ankle to neck; but this curve is all in one plane. The weight-leg and free-leg with the accompanying raised hip and lowered shoulder are all vertical and lateral displacements, visible from in front but barely appreciable in the side view; while, in similar fashion, the adjustments in the profile view, such as the protrusion or withdrawal of elbow and knee, are inoperative when seen from front or rear. The archaic control by linear contours drawn for the four cardinal aspects of the standing body has still survived, and explains why Pliny complains that

Polykleitan statues are too "square."[2] Praxiteles inherited and exaggerated this formula, accentuating the curves but still keeping them in the four cardinal planes. A fifth or early fourth century statue may be immediately recognized and dated by this adherence to quadrate composition. A full century after Polykleitos, Lysippos' followers are at last in command of the mysterious formula for the pose which shall yield expressive contours for every viewpoint. The refinements of pose are no longer merely frontal but pass into every plane, being based on a progressive rotation of the horizontal axes of the human body. Pliny's famous phrase[3] about Lysippos, *"nova intactaque ratione quadratas veterum staturas permutando,"* makes patent reference to this innovation.

If we draw an imaginary line through the two ears, another through both shoulders, another through both hips, another through both knees, another through both ankles, we shall have the five horizontal axes. If we make this experiment on a statue of the period of the Man with the Calf, we shall find these five axes all pointed in the same direction. There is no torsion to such a perfectly frontal composition. If we make the same experiment on some of the early Hellenistic statues, we shall find that the axes gradually turn like the needle of a compass so that the lowest one points at right angles or even in opposite direction to the topmost. This gradual torsion carried through the whole body is the typical early Hellenistic (or should we say Lysippic and Rhodian?) formula for producing an "omnifacial" composition. Thanks to its gradual nature, the elements in intelligible profile always explain the adjacent elements which are moving into foreshortening. As the axes are often distributed through a right angle or more, it is likely that there will always be some element in profile.[4] From the

employment of this formula comes the extraordinary completeness of each aspect under which the statue can be viewed (since each aspect is animated by the same formula as all the others), and the remarkably harmonious manner in which each aspect arises out of the preceding and melts into the succeeding one, as we move around the statue.

Excellent illustrations of an extreme use of the formula are the Dancing Satyr from Pompeii, the Seated Hermes from Herculaneum, the "Narcissus" or "Listening Dionysos" (all three in the Naples Museum), and the Borghese gladiator in the Louvre.

Naturally, not all Hellenistic sculpture is composed to this formula nor is the formula always carried consistently through all the axes; the axis of the head is least likely to conform since there is no obvious artistic reason why it should. It is no academic rule of perfection; yet it recurs with surprising frequency during the later periods. The formula (and I hope that this is now clear) is involved in the artistic necessity of making the two visible dimensions expressive of the representational content, so as to make the construction of the invisible third dimension[5] easy for us.

This process of construction, of defining the limits within which the solid exists, is assisted and facilitated in Greek sculpture by the use of patterns and planes to serve as surfaces of reference, as it were spatial determinatives setting the limits within which our spatial construction of the solid must operate.

(2) Planes of composition thus constitute a second device for facilitating our comprehension of spatial depth. The nearest point (to the eye of the spectator) at which empty air ceases and statue begins marks a crucial distance, since it is at

that point that our spatial construction of the work of art properly commences. If, however, the statue-solid begins for us not with an isolated projection but with a considerable surface all lying in one plane appreciably at right angles to the line of vision, the task of spatial construction is greatly simplified. And if, instead of a complicated system of varying distances from the eye, the parts of the statue are ordered together into a series of planes appreciably parallel to the front plane, the task of referring every portion of the statue to its exact proper place in depth is now reduced to identifying merely the plane to which it belongs and to ordering the planes in their proper succession. Finally, if there is a similar indication of a back plane behind which no element of the statue extends or protrudes, the eye clearly grasps the spatial limits (in the dimension running away from the eye) between which the whole statue lies, and proceeds easily and surely to construct the statue-solid in its extension between those limits.

Now it is apparent that in the case of a modelled human body there cannot be a true flat frontal plane (such as we have described) if for no other reason than because the body is everywhere rounded to a greater or less degree. But an effective and operative suggestion of a single plane can be produced by patternizing the lines and surfaces. It is characteristic of pattern that it pertains to areas which are seen together on an equal plane of projection. The pattern of a painting exists for us when we consider the painted surface as a flat area on which various patches of color lie; but the pattern vanishes insofar as we project the picture spatially in agreement with its representational content and read off these color-patches as objects of a real world in spatial perspective (in fact, as a *picture* instead of a decorative design). Insofar, then, as we vis-

ually hold together various surfaces and lines of a statue into a single pattern or geometric design which they make up, we tend to project them all upon a single plane at a uniform distance from the eye.

Pattern, therefore, forces curvilinear surfaces into a single plane and thus assists in the process of breaking up the continuum of spatial extension in the difficult third dimension into a succession of a few planes whose relative positions are more easily apprehended.

Pattern, it will be seen, works contrary to a three-dimensional apprehension because everything to which it applies is by it marshalled into a single plane. Yet if it is not presented too insistently, pattern will serve to simplify the *representata* and thereby assist the process of visual apprehension through which solid appearances are constructed.

(3) But the most potent elements in this whole process are the numerous devices of linear suggestion by which the third dimension is conjured up. These may be classed together and called "modelling-lines." When we make drawings in black-and-white, we may remove the look of flatness which attaches to surfaces between their outlines, either by appropriate suggestion of lights and shadows to suggest curvature or by adding properly curved interior lines. The Greek sculptor, adopting this latter device, carved lines whose curvature lay in the plane of the visible dimension in order to suggest a curvature in the invisible dimension. This is a little more subtle than it sounds. Unlike a painting, a statue, being actually in the round, possesses surfaces which are already correctly curved; but they may seem flat. The artist adds lines which do not follow the actual curvature of the projecting masses (since then they would no more seem curved than the whole surface in

which they lie) but whose curve, lying in a plane more or less at right angles, cannot fail to be fully visible. He draws, in fact, a profile of the curved mass and spreads it out flat on that curved mass's own surface.

If this is unclear to the reader, the instance of an identical procedure in the decoration of architectural mouldings will be helpful. Each of the mouldings of Greek architecture has its particular outline or profile as well as its proper surface-design or decoration. In their career along the side of a building these mouldings would tend to look flat. To obviate such an appearance, in certain conspicuous examples the linear designs of the surface decoration are based on the curvature or profile of the moulding. Thus the egg-and-dart uses the curve of its profile to bound the little shields or "eggs" of its characteristic design; the Lesbian cymation employs the ogee of its profile for the outline of the peculiar leaves which are its characteristic decoration; the outline of the little beads of the string-courses echoes the profile of the moulding on which it is carved, and the rectangular-profiled fillet or taenia uses the rectangular-lined meander. The essential of the whole matter is this: these curves (which determine and outline the decorative design) lie in a plane normal to the ordinary line of sight, so that they are clearly visible and not foreshortened, but at right angles to the plane of curvature of the mouldings which they adorn. Their function is to suggest the existence of that curvature by putting its outline into the visible dimensions.

This is just what is done in Greek sculpture, notably in the Pheidian period. The "Fates" of the Parthenon pediment are outstanding examples of modelling (that is, projection in the invisible dimension) suggested by equivalent curves lying in

the visible plane. The Venus Genetrix will serve for another example.

Perhaps it is not too much to assert that the sculptor who has not divined this secret (however unconscious he may be of its exact formulation) cannot practice his art with the highest success. An attentive eye will recognize this device in much of the best work of the modern masters, in Michelangelo very notably, but nowhere (I venture to think) so consciously and consistently carried out as in the "great century" of Greek sculpture.

The device of "modeling-lines" works directly contrary to the effects produced by patterns and planes. This, however, does not imply that these opposing formal methods are mutually destructive and inimical. Rather, the combination and just balance of their contrary influences in the same work of art constitute one of the remarkable opportunities of which a gifted sculptor will not hesitate to avail himself. The "Fates" of the Parthenon are again a most luminous instance and argument.

Thus: (1) by intelligible pose with its expressive contours, and (2) by planes of composition with patterns to establish them, and (3) by the correct application of modelling-lines, the third dimension is shorn of much of its obscure content, with the result that we apprehend the statue-solid directly in its depth and spatial extension. We apprehend it as a solid and not as a flat picture-like front-appearance behind which the invisible rest is assumed to lurk.

Let it be granted that as a result of all these devices we actually do construct the solid spatially, that we do apprehend its

depth directly and visually, in spite of the paradox that extension in the third dimension is invisible[5]—what then?

It is here that physiological esthetics may find it convenient to break off; yet it is just here that they might become most valuable and interesting. Clearly the mere trick of apprehending a solid as a solid by means of the eyesight alone is very remarkable and entertaining, and may evoke the pleasure attendant on a heightening of our ordinary physical faculties; it may be the *sine qua non* of specifically sculptural emotion; but equally clearly it cannot be thought to be the sole and direct cause of that emotion. The visual apprehension of solids may be an indispensable factor in the sculptural emotion; but it is not in itself an adequate description or characterization of that emotion.

It seems clear that we cannot progress farther unless at this point we take into account the representational element—the fact that the sculptor is not busy with a mere presentation of solids as solids, but that he embodies actual images of living beings and above all else delights in showing forth the human body. In Greek sculpture inanimate objects, except as the most minor accessories, were wholly ruled out during the fifth and fourth centuries. The lower animal forms occur in relief, but very seldom in sculpture in the round. Patently this was not mere accident or casual preference, but betokened an appreciation that the proper sculptural study of mankind was man—as though in some way the stereoscopic illusion obtained some secret value when it was concentrated upon an object which was after all essentially ourselves.

There is a present-day tendency among the initiate to consider the pictorial subject-matter unimportant and irrelevant to the artistic values. This may be a good corrective for the

persistent blindness with which a large part of the general public fail to see anything in art except the *representata*. Taking the illusion as a reality, they proceed to interrogate their every-day feelings toward the objects under view, considering them as if they were real objects in a real world. This is particularly true in sculpture and leads to much naive embarrassment in the presence of the nude. Still, there can be no doubt that the representational element is actually of the greatest import to sculpture.

The direct visual apprehension of a solid as a solid (which we have defined as the prime esthetic *differentia* of sculptural contemplation) is psychologically relevant but artistically unimportant unless the solid is also apprehended as an embodiment of an animate object. The sculptor's device is a means of giving us the most direct and intimate apprehension of the animate and animating qualities and forces of the object whose appearance he has imitated.

Whether or not we project ourselves sympathetically into the statue, I do not know. I feel that the cardinal objection to the empathy theories is their failure to measure up to our honest and actual experiences. They are partly true, certainly; but they make up only a small part of the mystery. They exaggerate a contributory factor into a paramount issue. Still, there is some very clear connection between our apprehension of the solid as solid in the case of a human statue and the fact that the only other method of direct apprehension of spatial solidity is our awareness of it for our own body. It may not be strictly our own strength or power of movement or agility or gravitational equilibrium which we feel to be heightened while we contemplate the sculptural indication of these qualities; but our power of spatially apprehending the statue as we spatially

apprehend our own bodily selves makes us immensely suscep-
tible and sympathetic to an emotional and almost muscular-
physical understanding of such qualities when they are sculp-
turally presented. We know them, not from the outside (as
we comprehend strength when we see a strong man pull or
push or lift, as we comprehend speed when we watch runners,
or agility as when we see a mountain-goat) but from the inside,
in terms of what they are for their possessor. And we appre-
hend them without strain or discomfort or other physical pre-
occupation. They come to us direct, simple, intense, sheerly
pleasurable. Herein may be the ultimate secret of the sculp-
tural appeal.

It is, therefore, not enough that we apprehend a solid as a
solid, nor yet that we comprehend that the solid is (let us say)
a human being. More than that, we must apprehend the ani-
mate and animating forces and qualities. We must apprehend
them not by an intellectual inference nor by a mere second-
hand sympathetic understanding; in sculptural contemplation
we apprehend them still more immediately, we feel them di-
rectly and as it were from within. The mechanism by which
this is accomplished is purely formal. It consists in devices of
line, surface, and gravitational arrangement, to which the rep-
resented object is made to conform. These devices are in them-
selves abstract, geometric, and little evocative of emotion; they
assert their magic only when they are correctly fused with rep-
resentational matter. So used, they are all-important; indeed,
the proper employment of these pure forms is the second great
secret of the sculptor's art.

At the risk of repetition, these pure forms of sculpture must
be here enumerated. They include all the devices of one-dimen-
sional emphasis which were discussed in connection with linear

presentation. Through these are occasioned various suggestions whose common characteristic is the absence of all suggestion of gravitational weight or mass. Then there are the devices of two-dimensional emphasis which were discussed in connection with relief carving. Of these the most notable is pattern; but there are numerous other ones, all dealing with the arrangement of areas. Through these are occasioned suggestions of size, internal structure, synthesis of forces, equilibrium, and other similar matters, of which the common characteristic is their suggestion of static mechanics without much suggestion of motion or of material solidity and weight. Finally there are the devices of three-dimensional emphasis, and with these we have already dealt at length. It is the fusion of the suggestions accruing from an artistically satisfactory use of all these formal devices which raises sculpture out of the category of a merely imitative craft which faithfully copies in terra cotta, stone, or bronze, the shapes and appearances of men, women, and animals, and makes of it an art with all an art's equipment for arousing emotions.

If it is true that the sculptural art borrows various devices peculiarly appropriate to certain of its sister arts, we can perhaps find therein one reason why artists are so frequently impressed with a sense of the community of all the arts, even though they seldom manage to bring this idea to the point where they can make clear what it is which they think the arts have in common. In order to do so it is first necessary to recognize the extreme complexity and variety of the esthetic emotions occasioned by any particular art and to sort out as many contributory factors as possible. One would then discover that certain of these factors recur in the esthetic complex of emo-

tions incident to other arts. If we have once come to recognize that nearly every kind of stimulus derivable from almost anything in heaven or earth may be associated in the state of a cultivated mind under the impression of poetical suggestion, we will not feel that there is anything unusual if the arts borrow various ranges of emotion from one another. It would be beside the point to make this analysis for all art; but on the basis of our previous discussion it should be quite easy to make this analysis for sculpture. It would read somewhat as follows:

The human body in sculptural representation differs from its prototype, the living body, by calling attention to certain qualities which otherwise tend to pass unnoticed. By being motionless it presses on our attention its particular volume and configuration. This immediate apprehension of the mass or volume of a represented object is the primary *differentia* of the sculptural appeal. This apprehension of a three-dimensional solid in terms of its surface aspect and its bounding-lines clearly recurs in the contemplation of architecture. In utilizing this, architecture accordingly borrows from the sculptural appeal. Our modern architects are not sufficiently aware of this. They are reliant upon paper plans and paper elevations; they design with one or two contours in mind, that is to say, those which they set down in these paper elevations. But when their building is built in three-dimensional matter, it will reveal a host of contours which these architects never considered; it will in fact be subject to all the devices which occasion the characteristic appeal of the sister-art of sculpture. Would not greater sensitiveness to this sculptural element save us from some of the paper-flat façades, unfeeling sky-lines, and brutalized corners with which our modern architects present us; or are the exigencies of rectangular building lots, retailed at

fabulous prices, fatally opposed to such an artistic renascence?
That all depends, in the long run, upon what we really want—
humanism or industrialism, the highest spiritual attainment
or the greatest convenience of the greatest numbers.

In addition to this characteristic sculptural factor there are
always other factors prominent in sculptural art. We cannot
see a statue without seeing its bounding-lines or contour; and
as we move around the statue this contour continuously goes
over into a different one, so that our emotional apprehension
of the outlines is not merely equivalent to an almost number-
less series of relief appearances viewed from points on the
circle, but also includes the transition of one aspect into the
next and the mental reconstruction of all these transitions in
agreement with the shape of the three-dimensional mass which
we have all the time been apprehending. There is thus a very
powerful and inseparable fusion of a linear element with the
mass element, and these two are in mutually complementary
relationship.

Thirdly, there is in sculpture the factor of chiaroscuro or of
light and shadow, intimately involved in that appreciation of
projections and hollows which determines our apprehension
of mass. But the distribution of light and dark constitutes an
arrangement of differently illuminated surfaces whose mutual
relations of size, shape, and position introduce esthetic factors
that are prevalent in the art of painting and drawing and which
may be called pictorial. Since every surface has a bounding-
line and may be diversified with interior line, a further linear
element has been introduced.

Lastly, all except very small statues impress us as having
weight; and even if we fail to be aware of the actual weight of
stone or metal and consider only the represented object, we

shall have a sense of weight and gravitational pull overcome in that equilibrium of forces which is the secret of the statue's balance and immobility. This sense of weight and thrust and balance is so prominent and characteristic a factor of the architectural appeal, that we may say that here sculpture borrows from architecture.

Clearly the importance of these various components or factors may vary enormously. In a figurine the sense of weight and gravitational pull is at a minimum; in a colossus its strength is enormously enhanced so that it may become one of the most prominent factors. The handling of grooved troughs and hollows and undercuttings will determine the range of dark and light, as will the depth to which light penetrates the material before it is wholly absorbed or reflected. Some sculpture is much more linear than other. Gothic has far more abundant shadow than Greek: Greek in general has more insistent line than Gothic. And these are but the most obvious and powerful components in a result which is after all as complex and as diverse as are the works of sculpture which men have made or the minds of men which have contemplated them.

After this survey of the principles and practice of Greek sculpture, it should be possible to understand somewhat more clearly the nature of the sculptural appeal as it comes to us from fifth and fourth century Hellenic art.

We have seen that the fundamental device of the art is the visual presentation of a solid so that it may be directly and immediately apprehended in all its spatial extent and depth; that because of the immediate and sensuous character of this apprehension, we are able to sense strongly and clearly the play of

forces which animate this solid, when we see it not as mere marble or bronze but as that which it represents, an animate being like ourselves (though perhaps a recognizably more harmonious and perfect being, devoid of the imperfections of material evils) and that finally certain purely formal devices of the art facilitate and amplify this apprehension of animating forces, which in turn reacts upon our own sense of animate energy. Out of this emotional apprehension, occasioned in this manner, arise all those feelings of physical animation, elation, exaltation, or whatever vague and inexpressive words we may use in trying to convey to others verbally a sense of our innermost experience from an artistically effective piece of sculpture.

Let it not be thought, however, that the foregoing is intended as an exhaustive account of the emotional content of the sculptural appeal. Purposely it has confined itself to the most distinctive and characteristic elements. But with these are blended amazingly many minor factors: our associations of every-day life, which are called up at sight of the represented object, would alone be a highly complex element, especially when we remember the range from mere sensuous delight to direct sexual stimulation that may be present in the contemplation of the nude. It would be foolish to assert that these associations are in no way present or involved. But apart from all such artistically extraneous elements (extraneous, since they reside more in the representational illusion than in the actual working of the art as an art) and amid all this characteristically human complication of elements, it ought to be possible to trace the dominant and peculiar emotional contribution which the exigencies and possibilities of the sculptor's art occasion; and this I have tried to do insofar as the conventions and un-

derlying principles of Greek art may be accessible to our anal-
ysis today, two thousand years after the disappearance of the
civilization in which that art was so conspicuously and success-
fully practiced.

Quite apart from all these devices of pure form, the repre-
sentational element in Greek sculpture was modified in the
interest of that quality called Idealism—the property of Greek
art which more than any other has been extolled and misunder-
stood by succeeding centuries of classical enthusiasts. Into the
true character of this "idealism" in Greek sculptural repre-
sentation of the human form it is essential that we should now
enter. In order to do so, it will be useful to discover first how
these idealizing tendencies arose, since they are, in their origin,
almost accidental inheritances from the primitive and archaic
periods.

Truth to Nature, fidelity to the actual shapes and appear-
ances, is the lodestar that leads the sculptors on. It is also the
song of the sirens, a Lorelei to bring their ships upon the
rocks; for in the very moment of attainment the true art of
sculpture goes to wreck and vanishes from sight, broken on the
reefs of a mere imitative realism.

That this is really so, may be easily (but not briefly) proven
by an examination of the history of any great epoch of sculp-
tural attainment, though we must consider both the technical
history and also the esthetic properties of sculptural form. For
my particular field of Greek art, I must assume that the his-
torical development is sufficiently known to permit a very
brief sketch of it in place of a chapter-long chronicle.

In its beginnings Greek sculpture was never truly primitive,
but commenced in an early archaic stage, having been spared

the phase of incoherent, clumsy helplessness of the completely untutored beginner. This rather anomalous situation is explained by the historic accident that the art of glyptic monumental statuary reached Greece in an already advanced stage of technical competence by being acquired by Ionian Greek visitors to Egypt in the seventh century B.C. In the course of the sixth century Greek sculpture evolved through its archaic period, a phase which by the opening of the fifth century had reached a high stylistic perfection without transcending the essential quality of archaism. This quality is accurately definable, and depends primarily on the employment of fixed schematic linear forms to represent the complex irregularities and variegated appearances of the world of sense. An artist of this period cannot master all the torsions and tensions, the projections and cavities which real objects present, but confines himself to a simple standard appearance from a single and favorable point of view. The long locks of hair which fall over the back and shoulders present in life a great complexity of disappearing and reappearing lines and surfaces; but the archaic sculptor devises a flowing zig-zag groove to suggest the general look of these long locks, and repeats this in parallel succession over the surface of stone which he has blocked out for the hair. Neatness of execution and sharpness of line become the obvious criteria of success, so that the great archaic craftsmen will carve these zig-zags in the most marvellous abundance and the most finished delicacy. But no matter how much they labor, they will not bring the stone to the appearance of actual hair, because the schema of the parallel zig-zag is only a geometric and conventionalized equivalent for the true surfaces and projections of the living model.

A different schematic design will be devised for the curled

locks over the forehead. Schemata will be found for eye-socket and eye-lid, ear, mouth, muscles of torso and back, fingers, toes, and all the rest of the body. And all the schemata will be characterized by a geometric simplicity and an unvarying repetition.

Consequently, as the archaic period advances, a wonderful decorative abundance of rather abstract linear forms will cover the sculptural surfaces more and more profusely till they seem as rich as tapestries or oriental rugs. This archaic craftsmanship, full of the most loving detail and the most engaging intricacies, makes a very strong appeal to the modern world, which has no difficulty in comprehending its devices and desires.

In Italian painting Botticelli stands near the culmination and close of the archaic period of his particular epoch of painting. One has only to look at the linear forms for hair, drapery, features, waves, flowers, and shore-line in the famous Birth of Venus, to discover over again all the schematic devices of late sixth century Greece.

Gothic sculpture in the twelfth century A.D. was passing through the same phase. So similar are its schematic devices that many an untrained observer will scarcely be able to tell you, in the case of two photographs of sculptured heads, which is archaic Greek and which is archaic Gothic.

In all these periods archaism dies the same death. Its final over-refinement forces a realization that it is flagrantly and fundamentally untrue to actual appearances. A period of simplicity ensues. The repetitions, the parallelisms, the minute scale for surface-lines, are abandoned. A few forms are used, but these are as like the real thing as the sculptor's awakened sense for realism can achieve.

The bronze charioteer of Delphi will serve admirably for illustration. Its simplicity is largely due to the preservation of the schematic devices of the archaic period, which are kept unchanged in their essential shape. The long vertical flutings of the drapery are unbroken in their career of alternate light and shadow; yet their profiles depart subtly yet sensibly from the set geometry of their implicit schema. There is almost the formality of a fluted column; yet, unlike such a column, the arris against the sky flickers and wavers, and the outline of the driver runs through a whole series of changing contours as we move around the statue. For the sleeves of the garment a more finely wrinkled schema is set, everywhere repeated, and everywhere tempered from strict parallelism and geometric repetition by tiny irregularities and departures from the norm. With the schematic forms for the hair, with the set geometry of curves for eye-brows and eye-lids, forehead and cheek and chin, it is always the same—the uneven tremor of life shaking the unphysical perfection of the mental constructions of an ideal geometry.

In all this, one point must be labored at risk of over-emphasis. To each element of the representation (free-hanging gown, close-drawn drapery, hair, features) there is alloted only *one* standard form, a schema based on the geometric simplification of the actual appearance, in conformity with its visual memory-image. This single form must be repeated as much as necessary in order to cover and inform the surface to which it applies. Thus the schema for free-hanging drapery must be repeated over all the drapery which hangs free. There results a clear division of the whole statue into areas each characterized by some peculiar line-form or pattern which everywhere distinguishes it and which is inherently appro-

priate to the representational intentions at that point. That is
why, in the art of this period, critics find no "irrelevant lines"
(how should there be; where would they come from?) and
are complimentary toward "structural simplicity" and clear
structural articulation. For the Greek these high effects were
no mystery. He was merely keeping to his inheritance of sche-
matic forms and tempering them in the direction of the con-
fused diversity of the real world. In consequence of his own
method, he could not fail to have his sensibilities awakened
so as to grasp the secret of large construction through simple
homogeneous areas and of simplicity of effect by correlation
of similar linear forms. The accidents of primitive draughts-
manship were beginning to go over into esthetic devices amen-
able to the imaginative volition of artistic creation.

Certainly, the archaic schemata are subjected to improve-
ment so that their fidelity to Nature is being constantly aug-
mented. And since the correct rendering of living shapes is,
after all, the supreme technical objective, we should expect to
see a very uneven attainment and even in the same piece of
sculpture find the traditional renderings side by side with un-
expected vivid and brilliant bits of naturalism. This is precisely
the quality which frequently occurs to puzzle the attentive
student of the period. The pedimental sculpture of the Zeus
temple at Olympia, the Boston counterpart of the Ludovisi
throne, the Esquiline Venus (if she be rightly classed as of this
period) reveal just this uneven command over true appear-
ances. But everywhere the framework of the older tradition
is apparent.

When the constant repetition of a set linear schema over an
entire plastic area palls on the sculptor (just as the uncritical
decorative parallelism of the archaic period had palled on his

predecessors) the transition period gives place to the period of strength, the age of the great masters of the Periclean period, the Athenian Pheidias and the Argive or Sikyonian Polykleitos. Naturally no break with the preceding generation is discernible. The schematic tradition still lurks under the linear presentations, and the very same forces which gave to the Delphic charioteer its harmony and simple greatness are still operative.

It follows that the work of the Pheidian period shows only an incomplete approximation to naturalism. In the preceding period truth to Nature tempered the schematic forms; now the schematic (and other more purely artistic) forms temper truth to Nature. Yet a complete truth to Nature can be attained only by a far-reaching and accurate grasp of detail, and this is too difficult to be achieved immediately; only the broader and more essential elements are recorded. There results a style of great breadth and power: the archaic has gone over into the strong period. The sculptor's attention is inevitably drawn to the larger formal effects of broad surfaces and conspicuous lines instead of to the multiplication of decorative detail. He learns what effects come from the balanced masses of unbroken surfaces and from the travel of an uninterrupted line, and his work gains immeasurably in power by the suppression of irrelevant detail which is forced upon him by his inability to fashion those details and to include them.

Pheidias and Polykleitos are the great masters of this period. The outstanding elements of their style are precisely those of the period in general. So, Michelangelo is the "strong" sculptor of the Renaissance. He could scarcely have been so had not his lifetime happened to fall in the strong period of his sculptural epoch.

It is in rendering drapery, rather than the nude, that the

formal devices of the high classic idiom are most effective
and conspicuous; for the sculptor is restrained by the fixity
of anatomic structure, but free to introduce his own inventions
in the pliant and shapeless fabric of anatomically untailored
Hellenic costume. By applying an optical inversion compar-
able to that which the vase painters had discovered when they
shifted from black-figure to red-figure design, the sculptors
of the mid-fifth century converted the incised grooves of ar-
chaic drapery into raised and protruding ridges and thereby
reversed interior detail on their statues from shadow to high-
light, conferring corporeal substance on what had previously
been merely linear indication of hanging folds. In the Olympia
pediments the sculptors are still experimenting with the new
device; on the Parthenon pediments, only a generation later,
the possibilities of the modelling line, the motion line, and
the illusion of transparent costume are completely understood
and applied with unsurpassable skill. With the advent of still
another generation, the inevitable exploitation of these fas-
cinating (but realistically inactual) artifices has led to the
exaggeration of a stylistic mannerism. While still under con-
trol on the carved parapet for the Nike temple, on the only
slightly later circular base of the Maenad monument all re-
straint has been thrown aside: the Strong has given place to a
Florid Formal Style as elaborately decorative as Late Archaic
and like the late archaic manner doomed to be supplanted by
a return to mimetic fidelity with its submissive recording of
actual appearances in place of formalistic fantasy. The Epidau-
ros temple sculptures from the opening decade of the fourth
century mark the end of florid formal extravagance.

Thereafter, as in corresponding times elsewhere, increasingly
close approximation to natural truth eliminates, one by one,

the artistic sophistications of fifth century classicism, as detail upon detail is correctly apprehended and embodied in the sculptural corpus. There comes a time when the more purely formal traditions of lines and masses, though they are still operative, are nearly obscured by these formally irrelevant details which stricter fidelity to Nature has introduced. Just at this stage and because there is so nice a balance between the illusion of objective appearance and the more geometric and abstract beauty of sculptural form, there arises a period of very great distinction. To most later-day collectors (and to all that period's contemporaries) this will seem the period of finest flower. It will, indeed, be the period not of strength but of beauty. It is the period of Praxiteles, of full-blown Gothic, of Raphael and Titian, of Benvenuto Cellini with his Perseus and Medusa, and the youth of Bernini when he did his group of Apollo and Daphne. In our collection of surviving Greek original bronzes, the "Ball Player" by some master in the Polykleitan School and the Boy from Marathon Bay directly out of the Praxitelean workshop are eloquent of the marvellous attainments of this period of beauty.

But the same force which brought this period on also brings its change and disappearance. The realistic details increase until fidelity to Nature makes most of the earlier formalizations impossible. The artists copy the human body as it is: so much the worse if it has not the formal elements of power and beauty upon it. If the theme involve drapery, they must reproduce Greek costume as it is in daily life and not as the formal resources of their art might like to modify it. The sculptor must find his expression through things as they really are. The stone or bronze is almost a replica now of the living model. The model therefore, like an actor, must itself embody the

emotional expressiveness which the artist intends to communicate to his public. Statuary is almost the craft of turning cleverly posed *tableaux vivants* into marble or metal. Human bodies are chosen as models for their own natural beauty, as in the Syracuse Aphrodite or the Capitoline Venus (or even for the stimulation from their ugliness or unusual qualities, as in the Gauls of the Pergamene artists); poses are reproduced literally for their physical attraction or their energy, strength and power displayed in actual use. This last period is accordingly complex and many-sided. It is not merely the period of Naturalism and Expressive Realism, but of Theatricalism and Sensationalism wherein (since everything must proceed from true and faithful appearances) the objects of the real world are tortured into striking and emotionally moving poses or combined in exciting situations. We have the Victory from Samothrace, the Borghese Warrior, the Laokoon, the Farnese Bull, and all the other familiar virtuosities of the Late Hellenistic Age.

With the culmination of this period comes the attainment of that goal which glimmered above the crude beginners of the art and led them to find geometrically simplified equivalents for the bewildering unseizable variety of seen appearances, and thereby opened up the archaic period. This same glimmering and unreachable objective destroyed the artificialities of the archaic, produced the simple forms of the strong period, gave the wealth of detail which turned the strong into the fine, and at last overwhelmed the period of beauty with the abundance of naturalistic detail. Throughout, the same power makes each period and destroys it, and at the last so dominates the sculptor's art as to leave no room for the other elements from which it drew most of its power and appeal. At the end,

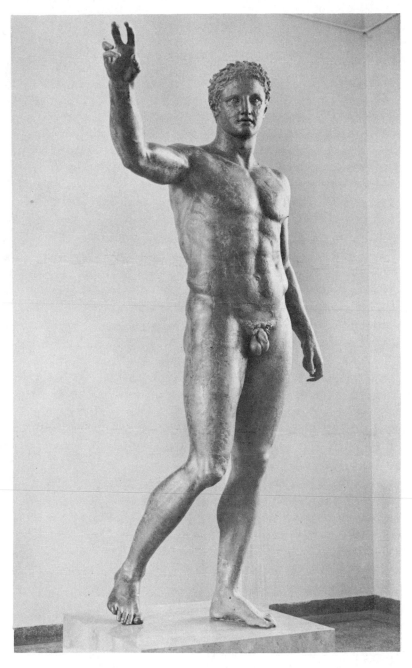

Bronze statue of an athlete (the "Ball-player"). Athens,
National Museum. Photo Alison Frantz, Athens.

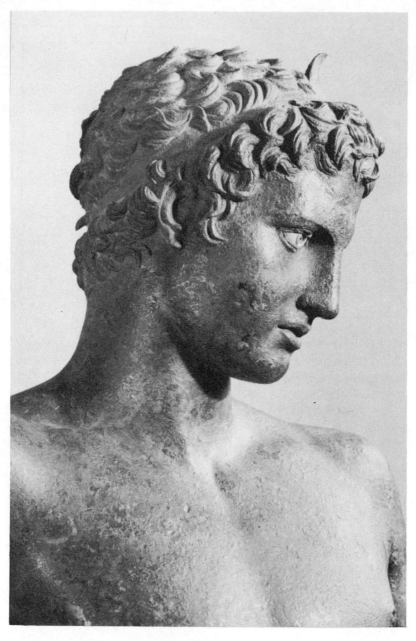

Detail of Bronze Boy from Marathon Bay. Athens, National Museum.
"To most . . . this will seem the period of finest flower. . . . It is
the period of Praxiteles."

when the goal is attained and no further direction of progress
is apparent, the sculptors, aware of the aridity of their success,
turn mournful and wistful glances back toward the earlier
periods whose naive delight and unsophisticated energy and
enthusiasm are denied to their accomplished and facile days.
Most of all, the period whose contrast with their own is most
flagrant, the period of ripe or even over-full archaism, attracts
them. There ensue "revivals," precious enthusiasms of the
dilettanti—the fads of the Neo-atticists, the enthusiasm of the
Augustan Age for Kanachos and Kalamis, in more modern
times the neo-Gothic, neo-Greek, and all the other resuscita-
tions which have made of modern architecture an eclectic thing
of copy-book and pastiche, the Pre-Raphaelites in painting, the
present-day enthusiasm for the archaic Greek and all unde-
veloped periods of artistic nascence the world over.

Sub specie aeternitatis, artistic epochs are cycles, each mov-
ing through identically the same phases under the same forces
to the same ultimate result. What most astonishes the student
of these cycles is the inevitable progress of each phase to its
own destruction, all because an artistically almost irrelevant
objective (fidelity to seen appearances) exerts a supreme con-
trol, while the seemingly true and relevant objective of the art
(control of the esthetic forms which determine the sculptural
appeal) is never clearly set up as the true one to be striven for.
Rather than the question—"What are the expressive forms of
my art, into obedience with which I must mould my matter?"
the sculptor seems to put himself the query—"Have I caught
the true look and fashion of the things which I portray?" Ap-
parently, the one criticism which artists have been least able to
endure or to meet, has been the artistically rather gratuitous
one—"You have failed to copy Nature correctly!"

Removed by lapse of centuries from the whole cycle of Greek sculpture, we can see that the works of each period have artistic value and that what seemed at the time to be progress, rendering one's predecessor's methods obsolete, was always realistic advance but not necessarily greater artistic achievement. How we are to rate these various periods for this, their artistic achievement, is a problem for the Canon of Taste to decide. Some critics will see the peak already attained in the late archaic, and class all subsequent products as decline; others prefer the period of strength, others the period of beauty; few will put their preference so late as the final stage of Naturalism or Eclecticism.

The present study, being an inquiry into artistic forms, must leave unraised the questions which belong to the province of Taste, and, without passing judgment on relative merits, must try to discover how the pure forms of sculpture were employed.

For the archaic period these "forms" have been abundantly studied; but it is essential to remember that they are in their origin artistic accidentals, mere devices of convenience by which the early artist helps himself out of the difficulties of imitating seen appearances, and that they only acquire artistic significance in proportion as the sculptors learn to turn them to account for purely artistic rather than merely representational ends. There is here a very present danger of confusing Origin and Validity (as the manuals of logic sometimes term this fallacy) and of imagining that because we have discovered how the various conventions and devices *arose* we have therefore fully explained and understood them.

In order to throw light on the peculiar conventions of archaic art, the behavior of savages and children has been much interrogated. The purpose is by wide-ranging comparisons to

elicit the presence of certain common conventions in all primitive art and to explain these conventions on general psychological or material grounds. The results have justified the attempt and have led to a wholly new understanding of artistic origins in Greece and elsewhere.

Briefly, these comparative studies have established the thesis that the primitive draughtsman does not draw from life but from memory. Those of us who have no knack for drawing may perhaps appreciate the unreasonableness in a demand that we should "just draw things as they look; put down what you see!" and realize that until a race has begun to learn to draw, the actual changeful appearances of things elude any attempt to find their direct and faithful linear equivalent. Primitive drawing is not so much a crude and incomplete rendering of the correct outline, as a sort of visual embodiment of those notions for which nouns and names are symbols.

We can perform the crucial experiment ourselves. At each of the names, "hut," "frog," "fly," a mental image is called up with more or less distinctness. If we try to transfer this mental picture to paper, we shall discover that it possesses some very surprising and yet perfectly reasonable characteristics. Since it is only a general image applicable to any of its species, it will show only essentials, but it will include all these. A quadruped must have four legs, a bird must show two wings; a human face will appear in full-front view or perhaps in profile with full-front eyes. In fact, a primitive drawing tends to be a mental construction exhibiting just those observations and analyses which the mind has made for its own pragmatic interests. Accordingly, we should not be surprised at finding in a primitive picture or statue of a human being an almost logical rigor. The right half of the body will have no reason to differ

in position or appearance from the left half; the head and eyes will turn neither to this side nor to that; the arms and hands will hang close to the sides or be raised evenly or be folded symmetrically. One lock of hair will look exactly like another, unless the artist chooses to record the different appearance of the short hair on the forehead and crown and the long back-hair, in which case there will be two hair-forms in use. Inevitably, then, certain set forms or *schemata* will be employed for the various parts—for head and face, with hair, eyes, nose, and mouth; for fingers, navel, chest, ribs, and so on.

How will primitive art advance, how will it improve upon this initial stage? Not by discarding these schematic forms, but by perfecting them so that they are more faithful to actual appearances, and by adding supplementary schemata for details which have been overlooked and therefore omitted. At each repetition of the standard theme of the erect nude male in early Greek sculpture you may notice some trivial improvement of the old or addition of the hitherto unobserved and new. But, however much this progress is continued, there cannot be more than a specious approximation to the photographically true and exact. Between the eye which sees and the hand which gives back the seen, there intervenes a something which never lies between the camera lens and the photographic plate: I mean the mind, to which the eye reports and from which the hand takes its instruction.

It is the charm of archaic art that it transmutes the vagaries of the external shapes of our ordinary world into the almost intellectual precision of these mental constructions and, by lavishing a most effective diligence on the perfect execution of each part, makes only the more apparent the mental conversion through which the natural appearances have been made

to pass. The more it labors for perfection, the more clearly it calls attention to its departures from objective truth, because archaic art can only repeat the generalized form (however minutely and succinctly) while Nature never shows this underlying type, but only the thousand and one individual variations of it.

Little by little this secret dawns upon the generations of artists. They discover that truth to Nature lies not in set repetition but in indefinite variation. The great problem (and the profound verity) of "the One and the Many" lifts upon their horizon. The form is one, but its manifested appearances are many. There is one form for the oak-leaf, another for the cypress; but when Nature makes an oak-tree, she does not hang it with a thousand identical leaves. Every leaf is different; yet every leaf exhibits the same form, which is the form for oak-leaves. In sculpture, the schematic designs for hair and for drapery-folds are retained as the basic structure from which every wisp of hair, every fold of drapery, is allowed to depart by a slight amount.

This is the period of transition from archaism to freedom, and sculpture which it produces shows a restrained and quietly severe beauty, as free from the affectations of merely decorative ornament as from the inconsequent lines and intentionless diversity of naturalistic imitation. In Greece this phase occupied roughly the first half of the fifth century B.C.

Because fifth century Greek sculpture inherited all the schematic forms for representing objects, it could not be true to life. At the time of Pheidias and Polykleitos, the sculptured human body was put together from a series of parts each of which had a more or less intellectualized shape or structure, and each of which had a consequent bias toward geometric

formalism and geometric simplification. The idealism, the "classic restraint," the omission of non-essentials, which are so generally acclaimed to be an outstanding mark of Greek sculpture, thus had their origin. Canova and Thorwaldsen and other neo-classicists worked by elimination, by deliberately trying to suppress complete natural fidelity: Polykleitos was still adding detail upon detail to his heritage and was striving to give to his inherited forms that freshness and vigor which only the desire to copy Nature can impart. They are going in opposite directions, the old Greeks and the modern neo-Greeks; and since we must judge them by their aims and ideals, we must allow that they are poles asunder in what they managed to accomplish.

The most lucid commentary on the art of Polykleitos is to be found in the lyric poetry of Bacchylides and the dramatic poetry of Sophocles. Both these masters worked with forms inherited out of the archaic period of their art; and both found their highest artistic opportunity in that minute and subtle modulation of the unrealities of formalism which would approximate more closely the real world about which (after all) they were writing. This, as far as I can understand it, is the typical mid-fifth-century mentality. It is only possible in a period where the public is familiar with all the artistic forms and conventions with which early art is trammeled, and so can appreciate the minute temperings of those forms by which the masters get their effects. On this condition depends the true Sophoclean "irony." Modern critics have often sighed enviously at the marvellous finesse of appreciation which they ascribe to the ancient Athenian audiences which sat in the Theater of Dionysos. But this audience was able to appreciate Sophocles because they had grown up in a knowledge of the

forms and conventions by minute deviation from which the Sophoclean drama gets all its tang and subtlety. It takes a similar training to appreciate Polykleitos.

We said that in the time of Polykleitos the sculptured human body was put together from a series of parts each of which had a more or less intellectualized or geometricized shape and structure. Out of these the sculptor put his figure together somewhat as the architect built up his Orders out of their component members. Now in architecture it was patent that the relative shapes and sizes of these members determined the fitness and rightness of the whole Order. Since the parts of an architectural Order are man-devised and not copied to imitate living things, the architect can determine their sizes to suit himself or rather to suit those peculiar demands of fitness and rightness. But if fitness and rightness are a function of relative shapes and sizes, they must be produced by ratios, by number. Number, at work in all the elements, engenders the perfection which is their beauty.

There was, in the fifth century, an obvious parallel between the architectural Order and the sculptural Order of the human statue. This, too, was put together out of parts each of a standard shape. Here, too, the fitness and rightness of the whole somehow depended on the relative sizes of these parts. What more natural than to draw the same conclusion and believe that Number here too was sovereign? Number is certainly sovereign in Nature to a most amazing extent (far more than we ordinarily dream, until we pick up a pamphlet on phyllotaxis or shell-formation or proportional growth), and the Greek may well have known this, especially as the Pythagoreans seem to have taught specifically such a doctrine. In any case there is little doubt that Number was introduced into

sculpture as it had been into architecture and, probably, into the vase shapes of pottery.[6]

The *locus classicus* is in Galen, where the following passage occurs:

Chrysippos holds beauty to consist in the proportions not of the elements but of the parts, that is to say, of finger to finger and of all the fingers to the palm and wrist, and of these to the forearm, and of the forearm to the upper arm, and of all the parts to each other, as they are set forth in the Canon of Polykleitos.[7]

Here we have a clear statement, from a somewhat late and round-about source, but expressed in just the language we should have anticipated. Commensurability of parts (συμμετρία) is the working of Number in sculpture and the earnest of its perfection. There is an almost metaphysical belief that beauty and the ideal type for sculptural representation are characterized by an almost supersensual, because intellectual and mathematical, structure.

This is not a unique or unusual turn for the artistic mind to take. It is not uncommon for artists to take refuge in formulae and to seek in canons and pseudo-scientific abstractions a sanction for sensuous artistic beauty. For example, in a period when geometric science and art were both in renascence, Albrecht Dürer of Nürnberg was obsessed to discover the underlying geometric and numerical necessity in the beauty of the human form, and he succeeded in producing a canon of perfection which was very full of Number. But he came to see that this canon was a standard from which to deviate, not a standard toward which to strive. This is just what we learn when we study the rôle of Number in the beauty of natural objects such

as flowers, leaf-forms, and shell-forms. The beauty of living things seems to involve a host of minute departures from an underlying geometric uniformity. The Canon is this underlying uniformity, the *eidos* of Greek philosophic speculation. It is made up of many numbers; but the mere literal incorporation of these numbers in an artistic representation will fall short of beauty because it will show only the mathematics and not the living thing.

This, I take it, is what Polykleitos was referring to in that often quoted and very generally misinterpreted dictum,—"He said that the employment of a great many numbers would almost engender perfection in sculpture."[8] Here the sting lurks in the seemingly harmless qualifying word *"almost."* By using a complex series of simple ratios it is possible to build up the coherent structure of an ideal figure—(as Albrecht Dürer was to discover many centuries later when he constructed a numerical canon for the human form, using as smallest unit of division a module equal to the 1800th part of the figure's total height!)[9]—but each one of these measurements must then be tempered a trifle, lest the proportions based on integral ratios be not quite true to natural appearances, where minutest irregularity seems to be the secret of personal individuality. It is in these little modifications of the canonic norm that the secret of bodily beauty is hidden. Failing to introduce them, by a trifle you will come short of success. As Browning felicitously phrased it (though in quite a different connection),

> "Oh, the little more, and how much it is!
> and the little less, and what worlds away!"

Accordingly, when we take actual measurements of these fifth century canonic statues or their replicas, we signally fail

to detect those simple arithmetical ratios which we must imagine the sculptors to have incorporated. This very much vexed and discountenanced an earlier generation of archaeologists. Yet the reason is not far to seek. The forms of architecture, being man-devised and conventional, owe no resemblance to natural objects, so that their proportions can be altered to suit man's fancy and esthetic sensibility; but only a slight alteration in the relative measurements of the human organs will overstep the limits imposed by sculpture's express aim and intention of representing under plastic form types of actually existent objects. If simple numerical ratios were not to be found at least approximated in Nature, they could not be introduced into sculpture, because sculpture was showing forth the general type implicit in individual appearances. Just as in architecture many of the simpler ratios were abandoned for more complex ones which should be more appropriate, so in sculpture (but much more rapidly) artists appreciated the necessity of abandoning strict ratios of simple integral numbers. But they seem still to have kept them as an unseen but operative frame-work of proportions. Nature and beauty strove for these ratios, but they were not attainable in earthly products; therefore the artist could not show them; but he must know them, and use them for his underlying structure, being careful to temper them in the interest of representational truth. The *temperaturae,* of which Vitruvius speaks as imposed on architecture by the accidents of human vision, occur also in sculpture where they are imposed by the accidents of material truth. That is why we cannot recover the exact ratios when we take measurements of Polykleitan work; but we ought to approach those ratios within fairly narrow limits.

Obviously the fifth century sculptor did not hold that he was

merely copying such and such an individual human being, converting him into bronze or marble. He was constructing on the basis of natural appearances a series of surfaces and shapes and lines which the eye could contemplate with satisfaction and the mind consider with approval and which it would recognize as the appropriate perfection in fully developed human kind. The natural appearances of objects must, of course, be followed as a corrective for all extreme departures and as a starting-point for schematic or formal deductions; but there was no thoroughgoing insistence that concrete individual objects must be reproduced just as they looked and were. The statues of victors in the games did not and could not resemble those victors themselves. Later ages, struck by the absence of portrait-like qualities in these dedications, invented such idle explanations as the story, which Pliny gives us, that only an athlete who had won a victory for the third time could dedicate a statue with his actual form and features.

Just as Pythios embodied his idea of the true form of an Ionic temple in the Athena temple at Priene, so Polykleitos embodied his idea of the true form of the nude male in his canonic Doryphoros. Pliny quotes Varro's complaint that the statues of Polykleitos were too much alike, *paene ad unum exemplum;* but that is just what we should expect of them, and the complaint is no more apposite that it would be to complain that all Doric temples are alike.

To summarize: the "idealism," the "classic restraint," the "omission of non-essentials," so characteristic of fifth century Greek sculpture, are all traceable to the attempt to put into material guise an almost metaphysical abstraction, a type-form which should satisfy the reason in its quest of perfection and through the senses lead it on to attain the supersensual. This

seemingly unsculptural and unreal trend originated in and developed out of the schematic forms of archaic art, which in turn grew out of psychological accidents wholly irrelevant to fifth century ideas. Here, as in all genetic processes, origin and validity must be kept distinct. To the Polykleitan age the individual forms of line and surface were not memory-images, but the inherited alphabet of the sculptor's art, with which he was to spell out physical perfection. Although Nature was always the check and the corrective, the sculptor was not aiming at reproducing her chance individual appearances. He did not imitate the casual, but the underlying permanence. His statues were not intended for replicas of unusually beautiful persons in unusually attractive attitudes. He did not make men as they appeared, but, in the deepest philosophical sense which his race could attach to the words, men as they were in their essence.

This is precisely the judgment which the greatest of the later sculptors, Lysippos, passed upon his predecessors, if we are to trust Pliny's report—*"Vulgoque dicebat ab illis factos quales essent homines a se quales viderentur esse,"*[10]—"He often said that *they* represented men as they really *are,* but *he* as they *appeared* to be." This sentence (like every other one touching ancient artistic criticism) has been consistently misunderstood. It has been imagined that Lysippos was distinguishing between realism and impressionism; but nothing could be more wide of the mark. We have only to look at fifth century sculpture to convince ourselves that, whatever the artists may have done, what they signally did *not* do was to represent men as they really are in Nature—that was an achievement which must wait for Lysippos and the Hellenistic schools. *"Ad veritatem*

Lysippum ac Praxitelen accessisse optime adfirmant," says
Quintilian;[11] and that ought to settle it.

Let us consider for a moment what sculptural impressionism
means. In painting, the incentive to impressionism arises out
of the discrepancy between the hypothetical distance at which
the painted objects are supposed to exist and the actual dis-
tance from our eyes at which they occur on the canvas, and out
of the difficulty of suggesting luminosity correctly. If we
merely paint on a reduced scale all the details which an object
shows on close inspection, the modifications of perspective
will not suffice to give us the illusion of seeing that object in
its proper setting of atmospheric distance. We must paint, on
the canvas close to our eyes, the look of that object at a dis-
tance, with all its blurred edges and qualities of color and
light. We must paint the retinal impression. This involves a
complicated problem of color values which will suggest these
effects of light, since painting cannot reproduce them directly,
but must evoke them by an equivalent construction out of her
own devising. Aiming at greater fidelity to seen appearances,
painting thus ceases to follow the materially "correct" outline
and coloring of objects; and the opposition between realism
and impressionism can thus arise. But in sculpture, where the
true distances are accurately given and fidelity to color and
light is greatly subordinated to questions of surface-forms and
outlines, impressionism in the sense just now indicated has
no obvious place or meaning. There is, however, a secondary
sense in which the term is sometimes used for sculpture. To
show an object as it appears is in sculpture to show it as it
actually is; but we might undertake to represent the object as
it seems to someone who is looking hastily or casually or under

emotional stress or under some bias of interest or judgment. Thus impressionism in sculpture comes to stand for something very much like emotional expressionism. It is not a normal "impression" such as the laws of optics and physiology would impose upon the normal seeing-eye; it is somebody else's impression, in the sense of a mental and emotional construction such as under proper stimulation we might be able to recreate in ourselves. Of all this, what is there in the work of Lysippos? A free use of massed shadow in the hair is the only impressionism that I can find ever ascribed to him; and the testimony of ancient writers and of extant works of his school and period point wholly the other way. When Lysippos said that he made men as they seemed to be, he was saying that he made them just as they actually looked. It was Lysippos who was the realist.

"Ad veritatem Lysippum ac Praxitelen accessisse . . ." Can this be true of Praxiteles? Critics have felt themselves at a loss because third century Alexandrian art, carrying on Athenian traditions, produced ultra-Praxitelean work and, at the same time, ultra-naturalistic genre. But there is no discrepancy or contradiction here. Instead of relying on the emotional power of abstract pure form, the Alexandrian school turned to direct pictorial presentation. In order to represent ugly, uncouth, bizarre, or ludicrous subjects, it copied these faithfully, down to every wrinkle and deformity: in order to represent beautiful subjects, it went equally far in the literal imitation of soft-textured skin, smooth and yielding surface forms, without edges and with veiled lines. It is simply a difference of subject-matter; the literal intent and the artistic method are in either case the same. For all his seeming idealization of beauty, Praxiteles is the immediate precursor of the Alexandrian realists.

When the schematic form disappears as the ideal norm of

reference, intelligibly present and definable in every instance to which that form applies, when instead the artist copies the actual appearances of objects without deferring to a mental construction or generic prototype, art enters upon its highest career of technical achievement. But its formal content is inevitably diminished and obscured; and at precisely this point in its career spiritual decadence sets in. In Greece this turning falls in the lifetime of Praxiteles (as in the sister art of dramatic literature it falls in the lifetime of Euripides). Lysippos foreshadows the decline. For did he not admit that his predecessors imaged men as they were in their essence, but he himself merely as they appeared (very much as Sophocles was said to have shown men as they had to be; but Euripides, as they were).

The reason why decadence begins at the very moment of seemingly greatest achievement needs no elaboration for those who have followed our previous discussions. The true artistic aim of sculpture has proved itself not to be this *ignis fatuus* of imitative dexterity and representational fidelity. To the sole, innermost, yet so frequently obscured, intention of the art as an art, we have already directed a detailed attention. If the argument for the true nature of the esthetic appeal and artistic purpose of sculpture be recalled, it will be obvious why, as estheticians, we must agree with the frequent opinion that the Hellenistic Age, however much it may mark technical advance, artistically is on the downward slope. *"Cessavit deinde ars,"* says Pliny for the period after 296 B.C., and, except that we might be inclined to set the year a little later, we may be tempted to agree with his pronouncement.[12]

IV

THE ESTHETICS OF GREEK
ARCHITECTURE

I MUST PRESUPPOSE that the history and achievements of Greek architecture are sufficiently familiar to the reader. He will know, for example, that the dominant form or theme is the colonnaded temple; that this is built with wall, column, and horizontal beam; and that the structural elements are the square-hewn, close-fitting, mortarless ashlar block, and the various members of two distinct and characteristic "Orders," the Doric and the Ionic, to the latter of which is allied a sub-Order, the Corinthian, scarcely differing from the Ionic save in the form of its capital. He will know, further, that there are temple remains dating from the sixth century B.C. and remarkable for their vigor and simplicity; that in the fifth century were achieved the refined and powerful buildings on the Athenian acropolis, in which the Doric Order reached its formal perfection and the Ionic its first flowering on Attic soil; and that in the two succeeding centuries the Ionic style was perfected by Pythios and Hermogenes and their respective schools, on the west shores of Asia Minor in such notable

exemplars as the Mausoleum, the Athena temple at Priene, the Artemis temples at Ephesos and at Magnesia on the Meander, and the long-travailled but never-complete giant temple of Didymean Apollo.

I must also assume that most of the technical vocabulary of the architect will convey its legitimate meaning to the reader, and that he has already noticed the obvious and salient virtues or limitations of the Greek style.

Thus he will know that it is a current precept that Greek buildings always express their purpose and the mechanics of their construction. A temple-plan is self-explanatory; its elevation never misleads us with any pretence—although it must be granted that it rather effectually disguises the building's interior conformation by spreading a flatly aligned colonnade in front of it. The entablature is not carved or moulded to produce a merely decorative façade: the epistyle has horizontal stressings to show its function; we may guess that ceiling beams bed behind the frieze; the cornice is unashamedly a water-shed; the pediment occurs of necessity because a sloping roof can end in no simpler or more obvious manner. The akroteria are the only structural non-essentials—and I am not altogether sure that these may not have been survivals of weights to hold down the roof, like the stones on Swiss chalets, or the interlacing of rafters.

We can scarcely acquit the Greek architects of having followed a third popular modern precept by making their architecture express its material, since they not merely painted their marble, but in the members of the two Orders carved forms (such as triglyphs, dentils, guttae, regulae) which were clearly imitative presentations of timber construction. Yet they exploited the good qualities of their building material, by giving

their marble walls that lustrous finish which still endures upon them, and by carving designs whose sharpness of line and shadow-free shallows emphasized those beauties which reside more in fine marble than in any other stone. On the other hand, they could not tolerate rustication or ruggedness (except for fortification walls and similar uses) but covered their coarser materials with a stucco of powdered marble which effectively gave the lie to its native qualities. That they sheathed exposed timber with terracotta or bronze cannot be instanced against them, since it was done not so much to disguise the material as to protect and preserve the wood.

There is a fourth precept to which good architecture is generally supposed to conform. It must express (it is said) the mentality and civilization of its builders—as though whatever man consciously makes could fail to be eloquent of himself! Even a Moorish tower upon a Renaissance palace built for the servants' hall of an American millionaire's country-place is eloquent of its age and culture. Eclecticism is as much a style as any other—and as significant of its attendant civilization. The sky-line of Fifth Avenue is very eloquent of the perturbed and composite culture that made it and enjoys it. But it is intended to assert by this particular precept, that the spiritual qualities of an age should somehow be deducible from the buildings which it produces; and it is clearly true of Greek architecture that it is ordered and logical, that it harmonizes part with part, and parts with whole, and that, to a most remarkable degree, it is unfantastic and, in all its elements and proportions, always implies a human use or service, and a mortal eye and a rational mind to observe and approve it.

There are no structural irrelevancies in Greek building, such as columns which are not the true supports of their super-

structures, or façades which merely mask with decorative additions the disparate structure behind them. But though there are no structural irrelevancies, neither is there much structural inventiveness or ambition. The Greek temple is, in its intent, a one-story affair. The superposed colonnades in its interior were forced on the builder by the physical necessity of supporting the roofbeams and the esthetic impossibility of doing so by means of a single story of columns (since these would have to be taller and so more massive than those of the exterior order). The two-story colonnade with ground-floor and gallery, thus produced, was often employed to line market-places and open squares, but seems not to have incited builders to attempt a third or a fourth stage of columns. The tower-like superposition of the Orders was reserved for Roman façades and the restless Renaissance to achieve. The stoa, thus limited by custom to two stages, was further restrained in its height by the characteristically Greek consideration that a column more than 12 feet high would seem out of proportion to the human beings for whose service and convenience it was intended. Here, as so often in things Greek, it seemed that "man is of all things the measure." The temples, being houses of gods or at least their images, were not cribbed and cabined by these demands of human proportion: their single story of columns (you would imagine) could swell to any height. But here another proportion stepped in to check their rise toward the colossal: the distance from column to column always bore some sort of established relation to the height of the shafts, and columns could not be too widely spaced lest they could no longer be safely bridged with horizontal beams of stone. The Greeks were timid engineers:[1] a 15-foot air-span gave them pause, and the lintel of Diana's temple at Ephesos was a gi-

gantic achievement. And so when they strove toward the colossal in height, their columns were allowed but barely sixty feet.[2] Except for such exceptional forms as the lighthouse of Alexandria and the Mausoleum of Halicarnassos, how many Greek buildings (like the Zeus temple at Girgenti) over-passed a height of one hundred feet? The theatres, to be sure, stretched up till their topmost rows might be more than this distance above the dancers' circle; but the seats were all bedded safely on the sloping hillside. For the Greeks before the Roman era, no hillside—no theater. Nothing is more surpris-ing than to sketch the elevation of one of the great French Gothic cathedrals and to the same scale superpose upon it the façade of any of the greater Greek temples. Where the two buildings chance to agree in width, as do the Parthenon and the cathedral of Chartres, it is all the more astonishing to see the Gothic pushing its nave to twice the Greek temple's height before ever it begins to stretch its tower and spires toward the sky.

Nor were plans varied or complex or ambitious.[3] The temple was the god's house and the depository for his posses-sions. What then should a god do with more than two rooms? When the cult-statue was housed and the dedications and sacred treasures were safely sheltered, nothing remained to do. A surrounding colonnade to accommodate the god's worship-pers, perhaps; but nothing more. The altar, if only because of its smoke and fire, was in the open air and escaped housing. A peribolos wall, marking out the god's acreage, often shut in indiscriminately temple, altar, and *ex voto* dedications. The Greek architect had no idea of the mysterious in setting or approach; a few chthonian shrines in caverns is all that can be cited. Nor did it occur to him that his god might house, dark

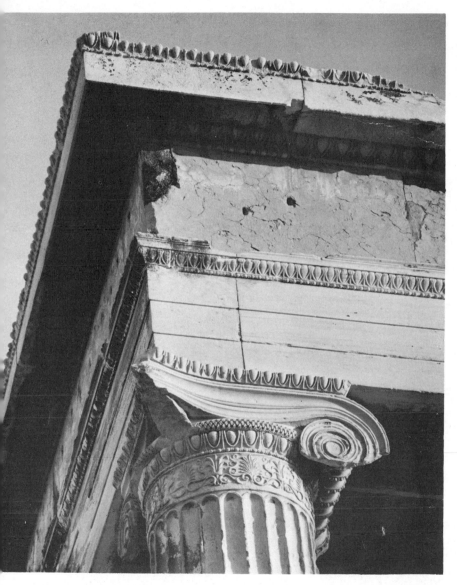

The Erechtheion, Athens. Stringcourse mouldings of
unsurpassable elegance. Photo Alison Frantz, Athens.

and inaccessible, beyond great walls and many rooms, approached through courtyard and hallway and stair, as the gods of the Pharaohs lived in the penetralia of Karnak or Luqsor. Nor were there kings to dwell in magnificent palaces. Even a sixth century tyrant was a man among men. Peisistratos might take the Acropolis for his house, and Dionysios might have his dwelling on Ortygia; but these were fortresses, not palaces. Even the princes of Hellenistic Pergamon have only a paltry bit of the great hillslope for their private places. The "palace" of Pericles? There was none. And the great fifth century Athens, which was responsible for the masterpieces of the Acropolis, was only "a poorly laid-out town"[4] of small mud-brick houses and crooked narrow streets. The greatness of Greek architecture is certainly not domestic, but lies in temples and public buildings of the *polis*. Yet how monotonous are the plans of the Greek temples! and although their settings are often wonderful — on the windy sunrise cape of Sunium, among the waste grey folds of Arcadian Bassae, under the shining frown of the Delphic cliffs—how much reliance is placed on Nature and how little does Art contribute! Delphi is as idly and irrelevantly marshalled as the accretions of a cemetery; Delos is an architectural pepperpot; Olympia is unconsidered and fortuitous; the Athenian acropolis—a crown of splendor upon a head of tangled hair—owes much of its effectiveness to the lofty, clear-shining aloofness of its site. Neither in the planning of the individual building nor in its relation to other buildings does the Greek architect show invention or artistic imagination. I do not feel confident that he even considered this latter relation until the fourth century: the symmetry *à peu près* in the arrangement of the buildings on the Acropolis may be very subtle—or very haphazard.

Mnesicles' unfulfilled design for the Propylaea, the town-plan of Halicarnassos and perhaps Rhodes, the carven giants against the gigantic masses of the Zeus temple of Akragas, the Erechtheum plan with its imperfect reaching-out toward a freer form[4]—a list of six or seven such items seems to exhaust the instances of original and powerful departures from the lucid but easy perfection of an established tradition. Two "Orders" and a variant—only that to show for the activity of centuries! Two entablatures and three kinds of capital—is that fecundity? is that inspiration? Is it then so hard for the human brain to invent, so impossible for it to create, that one of the most intelligent and esthetically most sensitive of races should have only this to show? They are very fine of their kind, these Orders and these temple-, colonnade-, tholos-, and theatre-forms; but under what limitations and abnegation of originality was their perfection wrought! And how could so many generations of active architects remain content to copy and re-copy from the same meagre repertory, as though there were no other way to build, no other plans or forms, nor even any other mouldings to be imagined, and as though to alter a proportion or to refine a subsidiary outline were achievement enough for any master?

How can we explain such absence of individual invention and artistic variety? Only by referring it to a deep-seated prejudice of the Greek mind. To explain this, there will be need of a short digression.

Under the perspective of time, the disputes of philosophic schools are apt to take on an appearance of fundamental irrelevancy. The real issues are usually taken for granted because they house so deep in the general prejudices and presup-

positions of the times. Aristotle pulled the Platonic Theory of Ideas to pieces, only to assert a very similar doctrine of forms in its place. From this it is fair to conclude that the assumption of visual prototypes for the various kinds of species of existent objects—to believe, for example, that the abstract concept "mouse" implies an actual mouse-form universally inherent in all mice and controlling their shape and appearance—came naturally and as it were necessarily to the Greek mind. Modern scholars tend to assume that the Greek philosophers derived these "Forms" out of the logical concept and out of the linguistic necessity of using a single word to name all the objects of a given class (as when we call all mice by the same word *"mouse"*). They look on them as a direct outcome of the behavior of human thought and the analysis of human speech. But in addition to all this, the Greek philosophy implies a trick of visualizing, of apprehending the characteristic shape and line by virtue of which all mice, for example, look sufficiently alike to be recognizable instances of their species. For the Greek mind there was always a concrete visual image somehow attached to the abstract universal concept. We ourselves use such words as "concept," "abstract term," and similar expressions which do not have any very clear metaphorical content; but Plato talked of ἰδέαι (things ἰδεῖν *to see*) or of εἴδη, which again are things *seen;* even the ordinary Greek work for "knowing" (οἶδα) had in it this same root of "looking" or "seeing." And most of the logical pitfalls by which the Platonic Theory of Ideas was beset are due to the concrete hard-and-fast *visible* quality (and therefore *concrete existence*) of which εἴδη could not divest themselves.

Reference has often been made to the peculiar qualities of light and atmosphere in Greek lands, to that clearness which

robs distance of its atmospheric mantle and that luminosity which deprives shadows of their power of plastic illusion, so that the eye sees in terms of contours bounding flat surfaces, and the brain remembers in terms of simple visual forms, or areas with sharp outlines and consequently very definite shapes. If we remember, too, that the Greek intellectuality (partly because of this extreme atmospheric lucidity under which the world of sense was presented to it?) was not "cloudy-minded" and "unearthly," but markedly observant of the external world and analytic of its phenomena, it will seem natural that such a race, highly intellectualized in the direction of observation and analysis, and immersed in a sense-world of highly accentuated outlines but rather diminished tactile and plastic values, should imagine its concepts as visual linear forms. Not the mass, not the material constitution, not the physical behavior, but the *seen appearance,* was for them the essential. To know what a thing is, they must know the *look* of it. The material might be comparatively irrelevant, since objects can be of different substance and yet have the same look; and matter changes so illusively (as when food turns into flesh and blood), while the form is abiding and amenable to the understanding. The matter of a man may suffer all manner of metabolism, but the form undergoes no such change; if annihilated in one individual by death or altered by mutilation, it reappears unchanged and undiminished in others of the species. Surely, if the Greek mind had not, instinctively as well as consciously, thus regarded the world of objects as a series of typical forms displayed and embodied in individual instances, Plato could never have imagined his theory of visual-forms or found an audience to which to expound it.

The objects which man makes—his implements, his places

of shelter, his furniture—these too come ranged in species, and each species has its characteristic form whose specific shape and appearance depend largely on the purpose or use of the object in question. The shape of a mirror is not arbitrary: its purpose implies that it should be the shape of the human face, its use suggests that it should have a handle by which it can be grasped and which will also serve it as a stand, for which purpose the handle should have a stable base. Thus defined, the necessary shape and appearance of a mirror lie within rather narrow limits; but among the various shapes which would satisfy the foregoing requirements, are not some more "necessary" than others? Is not the circle the inclusive proto-type of all face-shapes? For the handle and stand, will not certain relationships in the measurements and outline recom-mend themselves by the simplicity or coherence of their mathe-matical and logical properties, so that they will seem more nearly "right"? And do we not end with a conviction that even to such a man-devised thing as a hand-mirror there is a single fitting and perfect form which man can discover by experiment and thought? There is something of the eternal and supermortal about a form which is thus attained; it seems as though (like the truths of mathematics or logic) it must all the while have been in existence, implicit but unidentified. Almost it would appear as though the artist himself invents nothing: he merely sees more clearly than other men how things should be. The more he approximates perfect rightness in the forms of the things which he makes, the more nearly he has learned to materialize what the Divine Necessity has already constructed. . . . *"The craftsman, looking toward the true form, so fashions"* said Plato of such man-contrived things as couches and tables.

How then does the artist's activity differ from that of the philosopher, except that one gives *material* while the other gives *verbal* expression to the concepts which he discovers? It is the good craftsman's business to seek out the right form, which is the true and perfect species-type for the kind of object which he is making. And beauty and intellectual fitness will attend his discovery, because the true and primal types are god-made.

In Greek pottery, species appear and maintain themselves with the most startling definiteness of shape. Lekythos, pyxis, aryballos, hydria, krater, psykter, skyphos, amphora, kylix, kantharos—how distinct and distinctive they all are, each form rigorously determined by a consideration of its purpose and usefulness, with its own secret of grace of line and harmony of part! One comes to believe in their real objective existence as firmly as though they were genera and species of the animal world evolved by Nature. One can detect this same spirit in all the creations of the Greek genius: clothes, household furniture, tableware, all fall into type-forms characterized by an almost logical coherence and exactness.

The work of the architect will reveal a similar trait. If he plans a temple, his most conspicuous artistic duty will be to consider afresh the adequacy and rightness of the temple-form as his predecessors have sought it out and embodied it. What criteria can he use for scrutinizing their success or failure? Only those of that inner necessity by which a form is recognized as right and true. Whatever is unessential, whatever is not necessary to the temple for its purpose or stability or durability, is irrelevant to the form; it is not a part of the form, it is not a part of the temple. The expense and labor and time incident to the processes of building conspire to encourage

the architect in eliminating the superfluous. How then could there logically be different temple-plans, when there is only one purpose for which temples are used, one identical force of gravitation to combat and master, one rain and sun to oppose? There should only be variety insomuch as there might be inadequacy in expressing, or incompleteness in discovering, the true and right form. The Parthenon is not a different building from the temple of Poseidon at Paestum: it is the same building grown closer and truer to its proper and perfect semblance. Iktinos invented nothing: he merely saw more clearly how things should be.

But surely individual taste must enter in? The architect must arrange and vary details to suit himself or the preference of his patron? That might be the case, did perfection depend on artist or public; but neither of these can create right relations, they can only seek to embody them. One can tune the strings of a lyre to yield any pitch whatever; but the concords and dissonances do not depend on the musician or his public, but on the mathematics of the musical scale. Individual preference is but a chance guide to help the sensitive craftsman to the apprehension of those necessary and inherent harmonies which mark out the true form from all more or less imperfect approximations.

The rivalry between Pythios and Hermogenes, who lived over a century apart, was a contest to discover the same thing —the most just proportions for a series of architectural parts of established shape in predetermined sequence of arrangement, in fact the perfect norm for the century-old Ionic Order as applied to the century-old plan of the peripteral temple. And these were great architects, the greatest perhaps among the Greeks of their age, not because they had done something

new, but because they had done something very old a little better than anyone else had ever managed to do it. The Athena temple at Priene and the Artemis temple at Magnesia were claimants for one and the same title, that of *the* Ionic temple *par excellence;* their size, their use, their location, their cost were all minor considerations to this great distinction of being canonic, the perfection of their tribe and kind. In comparison with the differences which are apparent in any two Gothic cathedrals built within the same century, these two Ionic temples would be indistinguishable one from the other. In this Ionic architecture of the Asia Minor coast we can obtain a very admirable notion of the extent to which individual preference and invention were encouraged or allowed to assert themselves.

The impression that the Greek architects were merely seeking the right form, not striving to be original or emotionally expressive, occurs insistently. The proportions of the Doric Order change rapidly but consistently during the sixth and fifth centuries B.C. With the attainment of the right form in the Athenian Propylaea the process of development is almost entirely arrested. Later, the decidence of the Order from favor for temple-construction and the obvious need of a lightened entablature in the use of this Order for colonnades, entirely altered the ratios: the form was no longer right, an altered use had modified it. The profile of the Doric capital changes greatly during the sixth and fifth centuries; but after the time of the Propylaea the only important change is the slight straightening of the top of the echinus which makes the capital so much easier to cut—and entirely robs it of beauty. When the architects no longer appreciate rightness of form, the Practical and the Labor-saving are allowed to announce their wishes.

Until Hellenistic times there was only one important inno-
vation among architectural forms—the Corinthian capital—
and that was produced under logical pressure because of the
inadequacy of the existing forms. The Ionic capital posed an
insoluble problem at the point where a colonnade changed
direction (as at the corner of a temple), while the Doric cap-
ital could not be extricated from its use with the Doric entabla-
ture whose triglyph was a tyrannous nuisance with its inter-
ference in the free spacing of columns. Moreover neither the
Doric nor the Ionic capital strictly satisfied the logical require-
ments for the right form. The capital's function is to take the
entablature weight and transmit it to the column-shaft. As an
intermediary its shape should be consonant with those which
it serves: it should be rectangular above and circular below in
its cross-section, and in the intervening part it must perform
without effort the transition from rectangle to circle. The
Ionic capital does not meet these requirements; the Doric lacks
the transition; but the Corinthian will withstand the most
rigorous criticism. It is a marvellous metamorphosis of a circle
into a rectangle by a conventional device of leaves tied around
a shaft.

The development of the Ionic column-base from the crude
and unfelt forms of the Samian Heraion to the Attic or the
fourth-century Asia Minor types is a coherent and gradual
process. Contemplating it, we have the impression of behold-
ing in operation that which the metaphysicians call a Final
Cause, as though it were not each term in the series which
occasioned the next, but the ultimate and perfect form like a
magnet exerting its attraction through all the attempts of all
the earlier builders. Compare, in particular, the Ionic bases
of the Propylaea, of the east porch of the Erechtheum, and the

north porch of the same building: the last form lies in the first, and progress is as unhesitant as though the path were known and the goal sighted in advance. Equally impressive is the abrupt cessation of experiments and changes as soon as the right form has been attained. The profile of the north porch bases recurs some eighty years later on the monument of Lysicrates, almost unmodified, and the form seems to have imposed itself upon the ancient builders almost as authoritatively as upon their modern imitators. The Corinthian capital has much the same history; its form, once reached, undergoes little further change until late Hellenistic times.

This explanation for the extraordinary tyranny of the canonic form is manifestly inapplicable to all the elements of the Orders. The shape of a triglyph or mutule could not be deduced from the necessities of a roofed two-room shrine in trabeated stone or from any other intellectual formula or requirement. One could derive the column logically, but not its diminution; the capital, but not its profile; the architrave and perhaps the frieze, but not their scheme of decoration; the cornice, but not its profile. With the substitution of stone for timber in early times (for however much one may differ as to the detail of this timber prototype, it is impossible to refuse credence to it in some form or other) the structural justification for the appearance and pattern of regula, guttae, triglyph, mutule, fasciae, and dentils is their pretence of representing in conventionalized form the beam ends, planks, cleats, and even the nail-heads of timber-work transmuted into stone. Once established, these conventions survived through universal recognition of their artistic usefulness for articulating a structure which otherwise would possess little intelligible appearance. However inappropriate to limestone or marble

for their material embodiment, and however irrelevant to the
structural demands of squared and fitted blocks of stone, they
supplied a recognizable norm for imparting to an assemblage
of walls, ceilings, roofs, rooms, and corridors a unified, coher-
ent, and shapely appearance—in short, they transformed mere
masonry into a stoa or a temple. Precisely because strict archi-
tectural logic made no demand for the presence of most of the
elements which composed the Orders and could not dictate to
them either their shape or size or surface pattern, they escaped
criticism, censure, or attack. They had come into existence in
the early days of Greek architectural thinking and thereafter
persisted in their own right as established species—much as
there might be no discoverable inherent necessity for owls or
weasels, but there they were, and each had its distinctive and
established form. That is why throughout the classic period
these elements of the Orders found no rivals. The mind of
man might create all manner of other designs and decorative
details; but these would have no better necessity, no more
compelling reason for being thus rather than otherwise. Den-
tils and mutules and triglyphs might be equally arbitrary; but
there they were. They existed. As detail of some sort was
clearly needed to enliven and lighten the superstructure, these
decorative forms which speciously echoed timber construction
were retained. So it was that Greek architecture had only two
Orders.

Such an explanation, however, is not wholly satisfactory.
In other arts, decorative ornaments usually have a very well
marked career and run through a history with recognizably
similar stages. The ornament begins as a more or less skillful
and accurate imitation of some actually existing object of the
animal or vegetable or even inanimate world. By dint of repe-

tition it loses its fidelity and freshness, becomes stereotyped and conventionalized, and after a time may drift so far from its original appearance that its representational intent may be lost to the craftsman, who blindly reproduces a meaningless pattern. (The flower and marine motives of Cretan, Mycenean, and sub-Mycenean art may show the phases of such a development.) But in Greek architecture (though we find such naturalistic and living imitations as those of the Corinthian capital or some of the rinceaux of the simas, as well as such ultra-conventionalized ornaments as those of the leaf-patterns on the various cymatia), both naturalistic and conventionalized ornament, once they have been accepted for architectural use, undergo remarkably little further change. A practised eye can distinguish between a Lesbian cymation carved in the sixth and one carved in the third century B.C.; but as far as representational value or general pattern is concerned, the difference is slight. Only a specialist can tell in what century a given triglyph was carved or detect the difference between Ionic column-bases of the fourth century B.C. and those of the subsequent centuries. Why did the ancient architects cling so closely to forms and patterns that were neither necessary nor especially logical, but merely traditional and accepted fashions of the school?

Perhaps it would be pertinent to ask a closely similar question of the architects of our own day. Why are the old Greek Orders still retained today and why are no new Orders invented to supplement or supplant such hackneyed forms and formulae? When so much might be created, why only an uninventive repetition of a fashion that every eye must have seen a thousand times? In a word, why does architecture presist in having "Orders" at all?

Why, after so many hundred or even thousand years, has architecture so few devices in her copy-book? Is it really so hard to invent an Order, that we have only five or six for common service? And what, fundamentally, is this fetish, this jargon of the initiate, about "styles"—a Gothic "style," a Romanesque, a Greco-Roman, a pure Hellenic "style"? Who or what commanded that architects must keep to style, must copy and imitate and adapt, but not invent wholly new things for themselves? In literature plagiarism is held to be anything but a virtue and a pastiche is accounted worse than a "pot-boiler." Yet a wholly original, inventive, and unplagiarizing architect would never get a commission. How came such a deplorable condition?

It is perfectly true that examination of the historical process in which architectural styles and orders have come into being should warn us that the attainment of perfection is a tedious thing requiring the combined and successive energies of many men and outlasting the span of a single human life, so that it is the part of caution and sound sense to take from the past what the past has found good; but I think there is no other great art in which such a plea can be advanced or entertained. No doubt it is hard to write a good new piece of music; but the modern composer cannot therefore plead for privilege to take all his themes from Haydn and Mozart and his melodic developments from similar treatments by earlier masters.

Of course it is immensely convenient to trace off a good bit of detail from the Arch of Titus or the temple of Castor and Pollux; or to put the doorway of the Erechtheion *in toto* for the main portal of a modern bank; but if convenience is the only excuse for such a practice, it is high time for a new generation of practitioners to arise. Clearly there is some fundamental

principle which is operative in architecture, however out of place it may be in the other arts.

Contemporary critics often bewail what they term the *impasse* of eclecticism and pretend to see no hope for an art which makes past achievement its sole guide, counsellor, and friend. They have failed to observe that the tenacity of architectural tradition is due to an instinctive clutching for something permanent, familiar, and universal, on which to base diversity and artistic interest. The paucity of invention, the seemingly suicidal restraint of variety, are necessary because architecture is seeking to establish for itself a real world of recognized and recognizable objects. Painting has the seen world to draw upon: it does not have to create and establish its trees, rocks, streams, meadows, and animals, or waste any effort in persuading us that they are things which we already know. But architecture has to invent its world of objects first, before it can use them. And so, by the preference of generations of men, it settles upon those types and patterns which most commend themselves for their grace or expressiveness or utility or simplicity, and these become its world of real objects which it imitates and represents amid those formal relations which physics will permit and good taste commend. The fundamental in such a theory is the assertion that, in spite of appearances to the contrary, architecture tends to become a *representational* art, and that it imitates or represents a conventional world of its own creation. It is precisely because a Doric entablature is already familiar that it is artistically useful. The architect does not invent new orders for much the same reason that a writer does not invent new words, but uses the ones which are already known to his public, or that the painter does not invent botanical, zoölogical, and geological worlds of his own, but imitates the familiar realities of the ordinary world of sense. It should

follow, as a logical consequent, that the artistic intention of the architect will be unintelligible to anyone who is not already conversant with the traditional and conventional forms which he reproduces; and this is actually the case in direct proportion to the fixity with which the conventional forms are established. To the uneducated public the language of the classical Orders is wholly lost, precisely because they are unaware of its alphabet and phraseology.

Greek architecture, indeed, is the outstanding instance of this practice of establishing an artificial language by convention, in order to communicate architectural emotion. Gothic seems here (as in so much else) to have been of the other school and persuasion; yet for all its inventive freedom in profiles and shadows for the mouldings of piers and doorways, and its fertility of intricate decoration, Gothic seems to have been well aware that its freedom lay within very definite bounds and to have been scrupulously careful of the appropriateness of form to function. Gothic was a rich, picturesque language: the Greek Orders were as concise as the Greek philosophical vocabulary and consequently equally capable of subtle distinctions. Only he who knows the Greek Orders very intimately can really appreciate a masterpiece of Greek architecture. Though intellectually we may understand the intricate minutiae which occupied the builders' attention, perhaps very few today can really feel the emotions which these minutiae are intended to impart. They are like the subtleties of language which make the magic of great poetry: we must know the language amazingly well or we shall wholly miss the magic.

In discussing the ideal trend of architectural form, I have argued as though the *eidos* or right form were a changeless thing. But this is of course no more true of man-made forms

than of the forms of the natural world with their constant though inappreciably gradual evolution. Just as in the realm of plants and animals the species-type changes, so in architecture (but much more rapidly) the various standards change and evolve under the influence of tastes. So definite and so rational is this transformation of the Greek Orders, that it is almost possible to date any given building merely by assigning its place in this evolutionary process or by so seemingly arbitrary a criterion of date as the profile and pattern of the mouldings which served as string-courses separating the various elements of the Order.[6]

But if the form is dependent upon contemporary taste and subject to constant if gradual, change, what assurance could an ancient architect have that he had indeed found the right and true form? Since all the elements of his work were ultimately man-devised and man-perfected, what possible guarantee of their objective fitness could there be, or what sanction for their claims to be the best type? That is a question which the Greek must have asked himself. He found the answer just where we today might wish to find it—in science, though of course it was the science of his day and generation and consisted mainly of geometric theory.

It is an impressive discovery when the human mind first catches glimpse of the eternal supersensuous laws ruling the seemingly casual appearances of the world of sense. This moment came to the Greeks early in their career in the course of Pythagorean and other geometric investigations. In musical theory its appearance was most striking. Sounds—those intangible and invisible occurrences, seemingly unruled by anything but a fortuitous concordance among themselves—sud-

dcnly admitted their allegiance to the tyranny of geometry and number. The consonance of two notes was shown to depend on the presence of a simple integral numerical ratio between the lengths of the strings which produced them. Beauty and ugliness of sound were but functions of Number and ratio, and therefore founded on something measurable, something intelligible. Everywhere, order showed its control within the universe—in the paths of the stars, in the structure of material things—and everywhere, order seemed to be traceable to the influence of Number. If the right and wrong in something seemingly so elusive and unmeasurable as musical tone was based on Number, was it not even more probable that a similar geometric or arithmetic basis should determine right and wrong in the appearance of seen objects, which were material things, measurable and directly amenable to geometric notions? Nature is orderly. The forms for which she strives are strikingly symmetrical and numerically rational. The accidents of matter obscure and confuse the simple geometry of her intentions; but if we compare enough specimens of any species, we can eliminate the individual accidents and construct the true form. Here then is a cardinal assumption of Greek esthetic practice—that there is a true form for every class of objects and that such a true form is characterized by its geometric simplicity, by the commensurability of its component members. For if its parts be not simply commensurable, then complex and therefore less perfect numbers will enter and take the place of the more perfect ones which might have been employed. Commensurability of parts, συμμετρία, is consequently a test of rightness of form, and it behooves the architect to work by the aid of its precepts.

The generative ratio of the Doric Order was fixed as 2 to 1

in the earliest times of which we have knowledge. In the round building whose architrave was discovered in the foundations of the Sikyonian treasury at Delphi this ratio was apparently not followed: in Hellenistic times the entablature (because so diminished in height) is frequently poly-triglyphal. But between these limits of time, the ratio of 2 to 1 served for what may be termed the generative formula of the Order in its horizontal extension. To every normal column span we find (enumerating the elements as they lie one above the other)

> 1 column,
> 2 regulae,
> 2 triglyphs + 2 metopes,
> 4 mutules,
> 4 lion's-heads,
> (8 rows of cover-tiles?)

so that an ordinary Doric colonnade beats out a rhythm of full-notes in the columns, half and quarter notes in the entablature, and (frequently) eighth notes on the sloping roof, and even sixteenth notes in the floral ornamentation of the sima between the lion's-head water-spouts. In the Zeus temple at Olympia the measurements in ancient feet show how thoroughly and coherently the ratio was applied: the width of the roof-tile is taken as two feet, twice this measure gives us the width of a mutule with its *via* as well as the distance from lion's-head to lion's-head on the roof gutter, twice this latter measure gives the width of a triglyph with its metope, as well as the length of an abacus block, twice this measure gives the width from column center to column center, which is also the length of an epistyle block, and twice this last measure gives the height of a column. Finally, if the central akroterion of Nike was life-size, the total height from stylobate to peak of gable-figure

may very probably have equalled twice this last measurement. And so with 2 × 2 × 2 × 2 × 2 (× 2?) the exterior of the temple is built up, and the tacit assumption seems to be that the eye, contemplating these forms, will be rhythmically affected by the simple numerical ratios inherent in them.

A more sophisticated employment of numerical ratio occurs in the colonnaded portico which the late fourth century architect Philon added to the Hall of Mysteries at Eleusis. There— as building inscriptions state and existing fragments of the architectural elements confirm—the columns' lower diameter was set at six feet while the open floor-space between the columns was set at nine feet; half of the former dimension was assigned to the triglyph width, half of the latter to the metope width; and half of this last measure was given to the overhang of the cornice over the frieze.

The giant columns of Persepolis clearly betray Greek influence, and not least in their careful observation of numerical symmetry. The two fore-parts of bulls which carry the rafters are supported by a four-sided theme, each side of which has four scrolls or volutes (each decorated with sixteen-petalled rosettes) into which a four-filleted band has been wound; this in turn is supported by a capital whose upper portion shows eight, while its lower portion shows sixteen, floral divisions; below, a shaft with forty-eight flutings is supported on a base whose petal forms number twenty-four.

There can of course be no doubt of the conscious use of this simplest of all numerical ratios as a generative formula in the Doric Order, but it should not be imagined that all the measurements therefore will be found to be mathematically exact —all equal or double or quadruple—in the ancient Doric temples. In the Sicilian temples[7] especially there occur the

greatest irregularities in the spacing of the columns and the size of the various members. Much of this may be attributed to indifferent workmanship, since the eye really exacts only very general approximations to the mathematically correct in architectural ratios. But in the classic instance of the Parthenon it is a very difficult thesis to maintain that the irregularities are attributable to mason's errors or the architect's indifference to exactness. Rather it appears that the builders deliberately sought to temper the mathematically correct by slight departures from the "true" measurements, even carrying this ideal so far that they left no straight line straight nor any spacing equal.[8] We cannot fail to recall the practice of the sculptors contemporary to the Periclean architects, and particularly that reputedly Polykleitan saying concerning the "many numbers" which *"almost"* give perfection. The so-called "refinements" of Periclean architecture, the slight deviations from perfect regularity and symmetry, are not optical corrections for untrue illusions,[9] but are added in order to give life to the rigid mathematical correctness of the standard norm; they are departures from the "many numbers," out of which arises perfection. Certainly it is a very surprising thing that the Parthenon measurements cannot be reduced to feet and dactyls according to any common scale. A foot of .2957 meters will do fairly well; a foot of .3362 meters will apply with nearly equal success; but neither these nor any other unitary lengths will fit all the measurements, because they are integrally incommensurable. We can only conclude that the builders of the Parthenon (whether by intelligent imitation or by intuitive artistic taste) had applied to architecture the same secret of beauty which governs natural forms—the tempering of geometric accuracy by minute deviations in the interest of irregularity. I need only

refer to the extraordinary mathematical precision which under-
lies natural forms in the vegetable and animal worlds[10] and to
the patent observation that in any given individual of the spe-
cies the precision of the underlying form is always tempered
by the irregularities attendant upon the chance elements of
environment and growth, and add that we are apt to find the
actual slightly irregularized flower or shell more real, more
"living," and more artistically moving than the cold geo-
metrical perfection of the underlying form. The form only
lives when it is irregularized in matter. In architecture the
forms are man-devised; but if they are harmonized with math-
ematical precision and then irregularized in their material
presentation, they will acquire a status analogous to that of a
living thing in nature.

The esthetic value of using conventionally established archi-
tectural forms, or "Orders," is again proven. For only if the
forms are already established as species, can there be any
chance of success for this device of tempered irregularity which
will impart individual existence to each embodiment of the
species-form. The employment of the Greek "refinements"
would be neither useful nor explicable if these did not con-
stitute appreciable departures from clearly recognizable and
already familiar norms. As Greek philosophy might have
stated it, the *eidos* is characterized by mathematical perfection;
this perfection is somewhat obscured when the *eidos* is im-
printed in matter; but it is precisely from its minute deviations
and irregularities away from the standard form that the indi-
vidual instance derives its individuality and its right to a place
in the phenomenal world of sense.

There is a considerable body of testimony all tending to
ascribe a sense of the unliving ("rigid," "cold," "uninterest-

ing," are typical words) to buildings which display complete precision in their measurements, and a contrary impression of life ("alive," "warm," "elastic," "appealing," are frequent epithets) to the irregularized perfection of such buildings as the Parthenon.

It is not apparent that this principle of tempered precision was largely used after the fifth century. I believe that the fragments of later Ionic architecture show a very small margin of error, small enough to be unintentional on the part of the builders. The curvature of horizontal lines was largely abandoned, and the ideal of accurate perfection seems to have maintained itself thereafter in most of the Greco-Roman as in the Renaissance and modern classical schools; but these statements are subject to confirmation or correction.

In the Ionic entablature there was no obvious opportunity of setting up rhythmic accord with the columns by a simple ratio, as in the Doric Order. The Ionic architrave carries no vertical ornament, the figured frieze is horizontally continuous, the crowning mouldings of the members are too minute to be serviceable. There remain only the dentils and the sima. Of these, the dentils furnish a very clear vertical motive repeated in horizontal extension; but they are rather small, and the consequent accord of ten to fifteen dentils for each intercolumniation is not a relation which the eye would easily detect or from which it would derive any particular satisfaction. The sima, however, with its lions'-heads, could be utilized and—though the matter has not been thoroughly investigated—it would appear that the architect Pythios employed these lions'-heads to establish a 3 to 1 ratio with the colonnade. Thus, on his great work the Mausoleum[11] and his master work the little

Athena temple at Priene, the lions'-heads space three to the column interval, and are so placed that two out of every triad are exactly over the eyes of the volutes of capitals as well as over the edges of the column shafts at their mean height.[12] By this device the eye is led to single out at three levels (at mean column-height, at the capital, and at the roof-gutter) a horizontal measurement which recurs continuously, while every third recurrence of it is accented by a column. With this tri-partite division the dentils are not brought into accord on the Mausoleum; but in Pythios' later work, the Athena temple at Priene, there are five dentils to each lion-spacing. A century later, in the Artemis temple at Magnesia on the Meander, Hermogenes seems to have adhered to this same 3 to 1 rhythm.

　The same ratio also obtained vertically in the Ionic Order; for the entablature was rather evenly divided into the three elements of epistyle, frieze,[13] and cornice, while the epistyle was subdivided into three horizontal fasciae and the cornice into three elements, dentils, geison, and sima, though these usually were of unequal height. The Attic-Ionic column base showed three superposed parts.

　Plans and façades were also laid out to exhibit simple ratios. The length and breadth of the Parthenon stylobate are as 4 to 9. At Peiraeus in the arsenal which Philon built in the latter fourth century, the front, beneath the cornice, was a perfect rectangle, twice as wide as it was high; on the long sides the ratio of length to height was exactly 15 to 1. The interior floor space was a rectangle whose sides were related as 8 to 1.

　Finally, attention might be called to the predilection for "round" or perfect numbers. Athena's old temple on the Acropolis was known as the "Hundredfoot" and the sanctuary room of the Parthenon may perhaps have kept this measure-

ment for its length. The cella of the Athena temple at Priene measured 100 feet in length from wall-face to wall-face.

The use of Number penetrated into architectural practice much farther than the mere horizontal rhythm or the simple commensurability of the larger elements. In the fully established canons of the fourth and third centuries, in the work of the Ionic architects Pythios and Hermogenes, it would appear that every smallest element was dominated and determined in its measurements by numerical relations. In trying to unravel their skein of numbers, the student will discover that much of the commensurability may be ascribed to the architect's use of a foot-rule, and will be tempted to believe that this simple explanation is sufficient. Where stones were laid off to a measure of feet and dactyls they could not well fail to be commensurable. But since there were 16 dactyls to the ancient foot, divisions and subdivisions would have to partake of the nature of continued bisection: division by 3, 5, or 7 would seldom yield lengths measurable in dactyls. Yet if Dinsmoor's measurements of the Mausoleum fragments in the British Museum are correct, such commensurable but not measurable[14] relations were employed, and Vitruvius refers frequently to division into 7, 9, 11, 13, etc. It would seem therefore that the commensurability of parts is not an accidental corollary of the employment of a measured foot-rule, but an intentional artistic practice.

A further objection can be raised. Vitruvius, who must have had access to the traditional canons of some of these Greek architects (Hermogenes in particular) is full of rules of perfection. He instils commensurability (*modulatio* or *commodulatio*) by determining a modulus or unit with which to measure off diameters and heights and widths. Out of any measure-

ment so established a new modulus may be derived for fixing details and lesser elements in a design.

Thus, for example, the heights of mouldings are stated as fractions of the members to which they belong; the middle fascia of an Ionic epistyle is taken as a modulus for the geison; the diameter of the oculus of an Ionic capital gives the amount of projection for the echinus, and so on. This method of passing from one modulus to another is nowhere more clearly expressed by Vitruvius than in his description of the Ionic doorway. . . . From this example we see that though each member of the doorway is regarded as a modulus or measure of its immediate neighbor, nevertheless all are connected with each other and with the large dimension of the whole by a common measure. This illustrates the Vitruvian conception of proportion and there is every reason to believe that the standpoint of the Greek authors from whom he derived his inspiration was not essentially different.[15]

It is a frequent impression among modern readers and commentators of Vitruvius that these rules for the minutest details of the elements of the Orders are intended to be purely practical devices to save time and trouble with simple rules-of-thumb; and so they may have been in Vitruvius' own time— and since then. But all our discussion has tended to show that this is not the whole explanation, but that we have in these canons the echo of that old faith in the efficacy of Number to establish the perfection of the form.

I have dwelt a good deal on this numerical aspect of Greek architecture not only because it is philosophically interesting in its own right, but also because of certain remarkable implications which it involves. Out of Number come commensurability of lengths and surfaces and, by repetition, architectural

beat and rhythm. But all these in Greek architecture are only effective upon the spectator if the matter in which they are embodied is seen as in one and the same plane.

The rhythm of a Doric colonnade with its measured recurrence of columns moving past, while the triglyphs double and the cornice and roof quadruple the same steady beat—all this is effective, indeed exists for the beholder, only if all these elements are felt to be on a single surface or area or plane. Theirs is an art of related lines and surfaces, not of solids.

Now it is perfectly true that "inequality is the normal fact of optical appearance"[16] and that none of the equal surfaces of successive metopes or the equal spacings of triglyphs or regulae or lions'-heads will really be equal in our field of vision because of the perspective in which they are seen. But the mind has learned to correct the appearances which the eye encounters and to read off the true state behind the changes of perspective vision. But it does this, in Greek architecture, by the assumption of a plane in which all the unequal appearances actually lie with all their appropriate lengths and areas equal. It is by referring them to a single plane that the mind reconstitutes that recurrence of equal intervals on which the sense of rhythm depends.

It should follow that Greek architecture, in order to make its use of number effective, must have been an architecture of planes rather than of solids. This was precisely the case.

Instead of true depth, Greek architecture gives us successive and usually parallel planes. The stoa or colonnade presents the front plane of the exterior order, the middle plane of the columns which support the roof-beam, and the rear plane of the wall at the back. There is no sense of depth or enclosed space. Rather, the true depth has been converted into a succes-

sion of nearly flat and wholly disconnected surfaces—precisely as in archaic Greek relief sculpture. Even the roof, thanks to the straight mounting lines of the cover-tiles, joins in the vertical planes. The human beings moving in this colonnade appear to the exterior spectator like bas-relief on the rear plane.

With the temple it is, of course, the same. On the long sides there are two parallel planes, that of the colonnade and that of the naos wall; on the short sides there are three planes, that of the exterior colonnade, that of the vestibule colonnade and that of the rear wall of the vestibule (with or without its doorway with door or hanging). More complicated vistas in agora or temenos only add other planes. In glimpses across angles of colonnaded squares, or through corners of dipteral temples, the masses are all presented at intervals so that the eye sees a series of superimposed surfaces sharply divided by an intervening break of perfectly indeterminate extent. It should be added that the Greek atmosphere encourages this impression by eating up the air's appearance of solidity, so that space loses its density and surfaces seem directly superimposed.

Not all these planes are parallel since the colonnades surround the temple on the exterior and frequently the agora or temenos on its inner face. But only one angle is permitted, the right angle of 90 degrees. Just as the mind interprets the perspective of the stoa by its knowledge that it lies in a single plane, so it can proceed to the more difficult perspective of a corner if the angle is known and constant. The rectangularity of Greek plans is their most remarkable characteristic. Temples, temple enclosures, market-places, houses, and (after the fifth century) towns and cities are rectangular without break or pity, as the architecture of planes demanded that they must be.

And so there follows the most remarkable property of all in Greek architecture. Since its appearances all lie in parallel or perpendicular planes, it can only *define or bound solid space, and cannot enclose it.*

Just as there is no true depth to a Greek colonnade, but only the specious depth of Greek sculptured relief, so there is no sense of space shut in and contained in anything that the Greek builders made. Even the temple-interiors offered only more colonnades and walls in parallel planes, topped by a flat ceiling which was only another plane at right angles. Such a procedure bounds space, defines it; but though mechanically it contains space because it shuts it off, it is powerless to impart any such feeling to the human mind. Whereas a vault closes down upon space and makes space sensible, a panel ceiling merely ties the walls. In the terms of relief-carving, it acts like the straight edge or step between successive planes.

That these temple interiors were but half-lighted is perhaps an indication that artistically they were but half-felt or half-considered. They were but the space enclosed by the inner faces of the walls; they were the inside of the treasure-chest, serving to shut in the gold and the sacred heirlooms; and just as the outside of a chest has the craftsman's favor and gets the carving and gilding, so it was the exterior aspect of these enclosing walls which appealed to the ancient builder.

No doubt this is somewhat fanciful, and there exists a better reason for the opinion that interiors were the least successful aspect of Greek architecture. For it is of the utmost importance to note that Greek architecture had almost no need (of a direct practical kind) for trying to shut space in. Greek life was out of doors. The houses were mere sleeping-cells about a central patio, the theatres were unroofed gathering-places of the

people upon the hill-side; the market-places were open; even the shops were mere store-houses from which goods for the day's trade could be brought out to be spread in the open bazaar; the colonnades were but casual out-of-door shelters from wind and rain and sun; the schools were out-of-door palaestrae; the hospitals were colonnades in the sacred precinct of Aisklepios. Only the temples and the council-rooms so much as put the problem of enclosing air-space with encompassing masonry. Before the late Hellenistic age, domestic architecture hardly existed. It is not remarkable, therefore, that the architects devoted themselves wholly to external appearances or that, given the Greek conditions of atmosphere and light, they learned, as no other race has done, the secret of surface and line, but got no farther in the esthetics of their art than the expression of support in vertical parallel planes.

We may assert, therefore, that the Greek architects had no comprehension of the artistic handling of space in interiors. That vast preoccupation of Gothic and modern designers was to them a book unopened. If a paradox is permissible, their only interior compositions were out-of-doors, where the roof was the blue sky. In town-square and temple-precinct they composed spatial complexities; but the picture is always made of overlapping surfaces moving across one another as the spectator moves. The intervening depths are lost, just as they were lost for the ridges and gulleys and forests of their own beloved mountains which still today show like flat bas-reliefs against the Grecian sky.

Architecture makes its esthetic appeal visually, utilizing both two-dimensional and three-dimensional presentations of itself to its beholder. For two-dimensional presentations it de-

pends upon its appearance in the flat, as though it aimed at plane composition, with a design in areas whose mutually related shapes and sizes, colors and positions were the object of esthetic contemplation and the source of esthetic delight. Almost any façade is a composition of this kind. The Italian Renaissance carried to a high refinement and subtlety the art of such planilinear presentation. The fronts of the Municipio at Verona and the Grimani palace in Venice are instances of compositions for whose appreciation we shall need some feeling for the alternating rhythm with which wall-space and window-space, light and shadow, column and column, are held against each other for constrast of recurrent agreement.

Three-dimensional presentation may be most intelligibly explained as the effort of architecture to suggest the enclosing of space. In sculpture we saw art striving to impart a sense of space solidly occupied. In architecture we have a striving to outline, define, and limit space within an enclosing shell or boundary. It is not enough that walls and roof do actually enclose space; it is the artist's part to make them seem to do so, that the spectator may by direct visual apprehension be aware of this power and property of the builded thing. St. Sophia, seen from without—for all its clumsy contours—most patently succeeds in imparting this sense of space enclosed. To do so is indeed one of the original and distinctive qualities of the Byzantine style which differentiates it from the preceding Greek as thoroughly in the esthetic domain as the use of domes on pendentives marks it off in the mechanical domain. It is obvious that since architecture, unlike sculpture, is intended to be seen from within as well as from without, the artistic problem occurs not merely for the visual presentation of the exterior but recurs even more insistently for the interior. And

here, since the spectator is himself physically within the enclosed space, the three-dimensional presentation is of the utmost importance and carries with it an extraordinary range of emotional affection. The spectator is peculiarly at the mercy of every spatial suggestion, so that an almost magical power accrues to the intelligent master of this art. The apprehended space may bear almost no similarity to the actual physical space of such-and-such cubic volume which is determinable by measurement. One has but to recall the nave of a large Roman bascilica and that of a major Gothic cathedral to understand how little *à propos* are the actual dimensions of height and width.

It is just this power of three-dimensional presentation (so marvellous an achievement of the Gothic style) which I feel to be almost entirely absent in ancient Greek architecture. It confines itself to a two-dimensional presentation.

Indeed, I am tempted to hazard the seeming absurdity that the East Mediterranean people live in a *much less three-dimensional world* than the North Europeans. A visual space in which all distant objects tend to be projected upon a single plane would not present so much depth, so much three-dimensional solidity, as a visual space in which the correct distance of objects was more clearly defined. A race living in a spatial environment of the first type would incline in its art to silhouette drawing and flat "decorative" design. It is not accidental that Egyptian drawing never succeeded in indicating aerial depth and distance, or that a great power for enveloping painted scenery in atmospheric shadow arose in the school of the Netherlands. In Egypt and Arabia the shadow of a modeled projection tends to look like a dark surface in the same plane as its background and it is therefore disturbing to

the beauty of the design unless its superficial area and outline agree with the rest of the pattern. How much of the quality of pierced black-and-white ornament of Mschatta, Syrian Byzantine, and Coptic decoration is not explained by this atmospheric accident? And how much is not the Perso-Mesopotamian genius for decorative pattern in rugs and hangings and faïence a function of an atmospheric compulsion toward flat design and toward polychromy as a substitute for the chiaroscuro of varying projections and modelling? Conversely, in the rainy and foggy lands, third-dimensional depth is directly given in visual perception, since projections and shadows keep to their own plane and hold their distance. The repeated mouldings of Gothic portals and piers depend greatly upon this possibility of real spatial extension of objects in light and shadow. Is it any wonder that the deep portals and the great Gothic interiors never grew in Italian but flourished in Northern European air? And is it not a futility to take Greek architecture, calculated for visual projection upon parallel planes which the climate of Greece enforces, and to transplant it to Liverpool or Berlin where it will be riddled with depth, like a curtain shot through with holes?

Upon this two-dimensional character of its visual presentation Greek architecture based its artistic effects. Since support in the immediate vertical plane was all that such an art could present to the eye, all expression of weight sustained and held aloft must appear in the arrangement of lines and surfaces in the frontal plane of the Order. The entablature presses flat upon the columns and therefore can tolerate only horizontal or vertical lines in its decoration, since in this way the heavy uncomprising mass can be made directly intelligible. Our eyes follow the horizontal lines and our emotions instinctively in-

terpret such lines in terms of mass in a state of rest. We have experienced just such a sweep of line in looking at the horizon of plains or of the ocean: it is the line of things outspread, heavy and immovable and enduring, held by gravity, but in no danger of falling. The columns express in their contour successful but not effortless resistance to this downward pressure, which weighs squarely and heavily upon them until they bulge with the pressure. Here presumably is the psychology of entasis: it is the visible yielding to compression until a stable condition of resistance is reached. It establishes an analogy with human muscular effort and presents it directly to our emotional sensibility.

Obviously the Doric Order with its heavier and simpler entablature, more massive columns, and more pronounced entasis carries this appeal much farther than does the Ionic, which has comparatively a light and variegated load which it carries easily and with elegance. It is because of this direct visual presentation of the vertical support of a great weight not without effort, that the Doric temples are so "vigorous," so "powerful," so "enduring" and "eternal." The nearby rocks against which the sheep rub their flanks have lasted in their places longer than these ruined temples; but it is the temples which cry aloud that they are everlasting.

As long as the mere problem of overcoming mechanical difficulties besets and troubles the builder, he will take delight in visualizing through architectural means the weight of stones and the effort of holding them aloft. This is why so much early work of the human races is megalithic or massive or (where the race is artistically more sensitive and more gifted) more imposing and more able to impart a sense of great weight nobly borne. But when the mere mechanical obstacles cease

to be obstacles, the builder loses his feeling for the sheer op-
pression of weight and tends more and more to delight in im-
parting the very opposite sensation of stone poised aloft as
though it weighed nothing, and using it for a free fantasy of
imaginative constructions. The analogy between Romanesque
with the successive three periods of Gothic and the progress
of Greek architecture is therefore not casual but necessary. The
Doric Order is gradually robbed of its sense of size and weight
and the Ionic Order grows more and more universally popular
only to yield to a Corinthian Style which grows (before its
final decadence) extremely ornate.

The need for fluting the column is easily explained. Seen in
its out-of-door setting in the vertical plane of its Order, the
Greek column would appear as a thin, flat surface without
sufficient solidity to perform its function of support, were it not
for the flutes, the peculiar spacing of whose vertical shadow-
lines forces the eye to interpret the column as a rounded solid,
however invisible the curvature may otherwise be.

As in Greek relief, the third dimension is not suppressed,
but abbreviated. It exists to give substantiality to the content
of each of the various planes.

It is often said of Greek architecture that it has no method
of suggesting size because the members of the Orders maintain
such accurate relative proportion that there is no fixing of
"scale." So far was this accuracy of proportion carried that
correction was made for the apparent diminution of size of
distant objects by making them correspondingly larger than
strict ratio demanded, as when entablatures topping high
columns were given more than their strict proportional height.
(Cf. Vitruvius III, 3, 13.) Consequently, by eliminating even

that clue to actual size which the diminution due to actual distance from the eye might have furnished, the possibility of judging scale was wholly removed. This is certainly true; but it is also true that if any absolute unit of measurement could be introduced, an apprehension of the size of every part would follow, precisely because of this constant accuracy of relations between the elements. If it is recalled that Greek architecture was intended for public places, it will be evident that the Greek colonnade was usually seen with human beings standing or moving among its columns. The seen relation of column-spacing to the width of men's bodies, and of columns' height to the height of men, supplies just that absolute unit of measurement on which scale depends. We may understand from this why Greek taste tolerated the fixing of statues between the columns on the top step of a temple platform (as at Olympia) or the amassing of statuary in open agora and temenos. Just because of the orderliness of Greek ratios a human being or a life-sized statue could furnish scale to a degree wholly impossible in other periods and styles.

Greek relief, we have seen, was an art mainly of contours. If the insistence on the two-dimensional quality of Greek architectural composition is justified, it should follow that the Greek architects should have been extremely sensitive to outline; and this is notoriously the case. The corner of a Grecian temple seen against a luminous sky should be a revelation to every modern student. The broken line from step to akroterion is amazingly clarifying, in that it so clearly distinguishes and emphasizes every member of the Order. More than that, it helps to set the mass of the temple in equilibrium and stabilizes the whole structure. But again it is essentially as the bounding-line of a plane surface that this corner contour works on us—

as one can see from the extraordinary way in which its effect is heightened at night or against a sunset sky, when the temple loses its projection and solidity and flattens to a surface in silhouette.

Since its effects are calculated for presentation in a plane, what should have been the fate of the classic Orders in later times when the great discovery of architecture as an art of three-dimensional presentation had been made? They should have sunk to an ornamental accessory for articulating façades and other vertical planes. Actually, as early as imperial Roman times, they began to be used as attached orders without structural importance; and though purely Hellenic structures have continued to be built, it is largely as decorative motives that the forms of Greek architecture persist today. Their fate was thoroughly appropriate and deserved.

Like Greek music,[17] Greek architecture marks a stage of incomplete development in the evolution of its art. It exhibits the most enviable and amazing perfection of certain cardinal esthetic elements, combined with a complete ignorance of others no less important to the art in its fuller evolution.

Where mistakes are costly and production tedious, patrons and artists alike step warily. Printer's ink and paper, canvas and oils can be lavished, their cost is small restraint; but the hewn stones, the scaffolds, and the vast array of masons make architectural follies too prodigal for repetition. For this reason, though we may write for amusement and paint for pleasure, we seldom build except for use. Finally, though poetry can turn the hills upside down, live in the moon, and walk on thin crusts of water, though painting can remake the world to suit itself, architecture must rest a stone on a stone, even to span

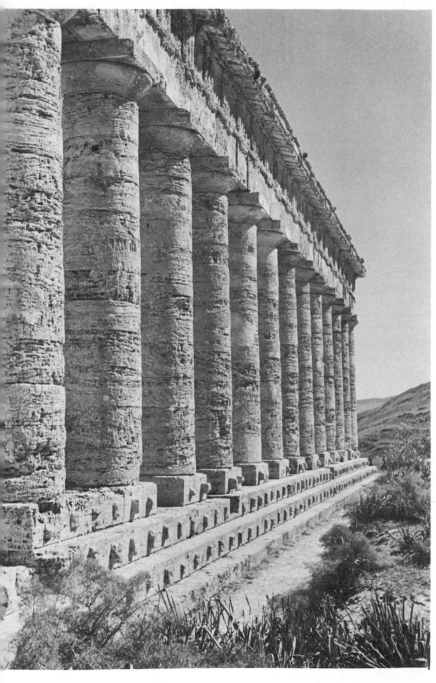

Unfinished temple, Segesta, Sicily. ". . . its effects are calculated for presentation in a plane." Photo Alison Frantz, Athens.

a void, and desist when the formula of gravitation says No.

Here, then, are three considerations which keep architecture within conventional rounds: cost and difficulty of production, practical aim, physical limitations. Because the claims of these three must first be satisfied, they have made tyrants of themselves and have even gone so far as to elevate their demands into a canon of architectural beauty.

Cost has declared: "A building is beautiful when no element of it is superfluous." Practical Aim has asserted: "A building is beautiful when it expresses the use for which it was made." Physical Limitation has maintained: "A building is beautiful when it expresses its construction."

Each of these claims contains enough of truth to give it an obstinate hold on popular opinion; but in each case the dogma is an unjustifiable inversion of negative into positive values. Thus, it is entirely true that structurally irrelevant decorative additions distract attention from more vital properties such as harmony of proportion, intelligibility of contour, coherence of solid mass; but it is not true that the suppression of these "superfluous elements" will insure beauty for a building that is not independently beautiful by virtue of its own qualities. Again, if a building does *not* visually and formally convey some sense of its intended use and purpose there is clearly a twofold offense, logically against practical judgment and esthetically against appropriate emotional response. But the positive proposition that a visible presentiment of a building's utilitarian function or structural intent is, in and by itself, any warrant of architectural attainment does not follow on any rule of reasoning. Finally, if a building appears to be supported by columns and beams while actually it rests on concrete vaulting, our like of straighforward dealing and our dis-

like of deception may strongly influence our esthetic judgment. But once again this negative proposition may not be inverted into a positive canon of taste. In and for itself, merely forthright visibility of constructional material and method may just as probably attend an artistic monstrosity.

For years I have tried to persuade myself that my pleasure in a Gothic cathedral was derived from an appreciation of the marvellous balance of thrusts and strains, that I approved of Roman aqueducts because they were nothing but arches reaching up to a level at which they could make water flow across plain and valley to a far-off town, and that the plan of a Greek temple was a perfect thing because it showed a room for the god's image, a room for the adorant, a preparatory vestibule, and a surrounding portico with shelter from sun and rain—just the things that were needful, and nothing more. And all the while secretly I knew that I was persuading myself with an intellectual theory and that the whole thing was simple self-deception, that I was taking a contributory element for sole cause and criterion, and that I liked Gothic cathedrals and Roman aqueducts and Greek temples for much more simple and less round-about reasons, that I liked them not because they expressed this or that, but because their looks appealed directly to me. I liked them not merely for their intentions, but for what they were—so much stone in such and such shapes. In fact, just as I liked music for what I heard, I liked architecture for what I saw.

I suspect that most of us must pass through some similar experience before we are prepared to accept any of the theories now to be developed. As long as we are persuaded that the esthetic of architecture is based on materialistic tyrannies such as utility and economy, we relegate architecture to a different

category from that of the other arts. No doubt, an architect who does not practice economy or emphasize utility will run the risk of being rightly refused employment. But this is merely to say that an architect should be a good engineer, and is not at all the same thing as to maintain that engineering and architecture are one and identical. I should like to see engineering defined as the science, and architecture as the art, of construction; because, if once we can dismiss the science by fully allowing its necessity and importance, we shall have an opportunity to discover what the art is.

Engineering was a vital matter to the builders of the pyramids, who seem to have mastered its elements so well that their mechanical adroitness has rather puzzled succeeding generations. But does that fact give us any hint of the real reason why the pyramids impress us as they do? Surely the primary reason is because a simple and elementary shape is presented in a gigantic size. And that is all there is to it. The rest—the difficulties of construction, the nearly 5000 years through which they have endured, the desert sand on which they rise, our imaginative and historical impressions of Pharaoh-ruled ancient Egypt, our literary enthusiasm for Cleopatra who had nothing whatever to do with the pyramids—all contribute, joining and fusing themselves to a complex emotional reaction; but they are not the fundamental of the architectural emotion, to which, indeed, they are in one sense thoroughly irrelevant.

In late Gothic fan-vaulting, the visible elements express a structure which is not merely physically absent, but is physically impossible. The ceiling in its periphery rests upon the ribs, the ribs rest upon the central ornament, and this in turn rests upon—nothing! Were the forms clumsy, the lines oppressive, or disconnected, the spectator's emotion, I imagine, would be

one of terror and fear; but because the lines are stable and buoyant and strive upward, our emotion is one of delight. Mass has lost its oppression; it floats upward like the Walhalla architecture of the thundercloud. We know it cannot be, yet we see that it is. Is it not captious and pedantic to complain that Henry VII's Chapel is not good architecture because it violates a fundamental principle of the art? Rather we should reconsider the validity of our assumed principle in the face of such a refutation of its authority. Again, what of the dome of St. Sophia that does not seem to come down with any weight upon its four pendentives? Let us not insist that good architecture must express its construction. Let us say that to express structure is one of architecture's sources of appeal, and that good architecture accordingly expresses structure vividly, immediately, appealingly, stimulatingly, what you will, if only you will leave the art free rein to do what it chooses with its own esthetic devices!

What of the façade of St. Mark's in Venice? If we removed everything that did not contribute to constructional necessity or practical use, I have a very shrewd idea of the result; for the structure is based on pre-Gothic methods of building while the ornamentation is Gothic. Is there not something of blind obstinacy in insisting that the Gothic ornamentation is therefore an unpleasant accretion, because it is structurally irrelevant?

Or of what use in architecture is color, except when it helps to emphasize structure and utility? None; therefore it is really irrelevant? Architecture calls in the arts of design to make her finished work more pleasing? They are accessory, not an integral part of architecture? Blind obstinacy again. Because a building will stand as well, in whatever way its walls be

"decorated"; because a green arch will last as long as a red one; because a mosaic is in the surface, and not in the mechanics of support; because color can be put on after the work of building is ended; because of a host of reasons such as these, color is dubbed irrelevant to architecture. True, since color and construction are in different categories, color may be wholly irrelevant to engineering; but why irrelevant to architecture? why accessory just because, in the making, it is usually subsequent?

May there not be a more purely esthetic aspect of architecture, in which it appears to us as an emotional art in three dimensions which employs pure forms in a visual appeal, working on our susceptibilities of mass, outline, color, and pattern, our muscular sense of balance, of strain, of freedom of motion and confinement, of size and weight and power, and embodying all these in a construction whose right to existence, because of its human utility and structural sanity, our reason approves?

By such a definition I refer to nothing abstruse or oversophisticated. A high, black wall projecting above us in a narrow street with squat overhanging masses is terrifying even when our reason assures us that it cannot fall. A colonnaded street like that of Palmyra, with its perspective narrowing toward a vanishing point, gives us a sense of reach and distance for which the actual linear extension seems no adequate warrant. The vertical lines of ribbing and grooving in a Gothic pier give an immediate realization of height which a smooth shaft would not impart. A great space easily crowned, like St. Sophia with its dome on pendentives, gives us a sense of freedom to move; while the hall of a thousand and one columns underground, the Ben-bir-direk, makes a nightmare of

the thought of bodily movement through space. It is with a pleasurable confusion that the eye loses itself in the weltered glory of Gothic rose-windows filled with stained glass, and an unconfused self-certainty with which we greet the picture-less sharp outlines of a Greek temple against the sky. These are simple, almost grossly simple, examples of emotions to which we all yield, because they are not supplied *by* us, but *to* us, being inherent in the very lines, surfaces, bulk, and color of the things at which we are looking. Here, as in other arts, pure form is at work, giving us the primary emotions to which all our sophistications of historical, mathematical, cultural, and critical appreciations or associations are accessory.

What then are these pure forms of architecture?

All the forms for painting and sculpture seem to belong to architecture as well; but because they are not so obviously made to fuse with a represented object, they cannot appeal to us so strongly. They remain more nearly in a state of pure form —concrete enough, since they are exemplified in stone or wood or plaster, but not merged in something other than themselves. In lieu of imitations and illusions of real objects on which these forms are overlaid, architecture shows us only certain conventional entities—simple elements such as columns, capitals, triglyphs, piers, groins, dosserets, or composite elements such as porticoes and blind-stories. Perhaps—as was suggested previously—we can here discern a reason why architectural tradition clings so tenaciously to its own artificial creations, such as its five classic Orders with all their specifications of proportion and detail. For if columns and capitals must be shaped just so, and not otherwise, they acquire something of the definite individual reality of a product of nature. A column

seems to be a column, almost as a dog is a dog or a tree is a tree. The architectural elements become part of the world of our ordinary experience. There may therefore be a closer parallel than we should have thought between a painted pattern expressing itself on a landscape and an architectural pattern expressing itself on a classic structure. Both landscape and classic Orders are repeated from the familiar forms of our visual experience. And the parallel with sculpture is even closer. Where the sculptor imitates living objects, the architect imitates the objects of a traditional world of recognized shapes. Both sculpture and architecture are representing something other than what (materially considered) they actually are.

In saying that architecture employs the pure forms of painting and sculpture, I of course am not referring to the familiar fact that architecture uses these arts for decoration. I mean that a building's façade may exhibit pattern, balance of masses, visual guiding lines, just as a painting might do, and employ flow or break of outline, suggestion of weight and resistance and balanced strain, just as a piece of sculpture might.

But in addition to these now familiar forms, architecture has her specific opportunities to work upon our emotions. We are always external to sculpture, but the works of architecture enclose us spatially, hem us in and ring us round with vast masses of stone many times our height and weight. Not only do we crane our heads, focus our eyes for distance, perform actual physical exertion in moving from point to point; but we are at the mercy of suggestions of confinement, freedom of movement, oppression, physical danger. Our eyes travel up with us easily to vast heights, or struggle hopelessly over the horizontal barriers which keep us down. We have vast cisterns

of air to breathe, or our lungs gasp under the illusion that we are closely shut in. There is, indeed, an entire range of bodily experiences, for the most part not very prominent in our consciousness, to which the formal suggestions of architecture may appeal. Such are our sense of poise and bodily balance, of muscular self-control, accuracy of movement, lightness and agility, feelings of strength and self-assurance, freedom of breath, even such vague bodily states as accompany security of footing, indifference to external forces, determination and endurance, boldness and fatigue.

Thus analyzed and put into words, the sensations of which I have been speaking as aroused in us by architectural forms seem artificial and unreal. Actually they lie so lightly on us that *qua* physiological conditions in us we are seldom even conscious of their existence, but tend to ascribe them as actual qualities to the architectural object. But I do not wish to insist on the psychological or physiological mechanism of artistic emotion. The essential thing for my purpose is the recognition that what I have called artistic form appeals directly to certain sensibilities in us, and leads us to ascribe to the work of art emotional values with which we should otherwise have no acquaintance. That these emotions or qualities are in the building is precisely the opposite of my meaning. These things are in *us,* and it is to our sense of them that architectural form can appeal. When we exclaim at the lightness of crocket and finial, there is no gravitational lightness in the carven stone. We are apt to speak as though tracery were done in pumice and wall-bases in solid ore. A chisel may remove only a few ounces from the actual weight of a stone, yet the stone may thereby become so light that it almost floats in air from its own buoyancy; for the sense of its lightness is in ourselves. The common sense

behind traditional ways of speech bears testimony that these are familiar human experiences and not mere sophistications.

But we ascribe the lightness to the stone. The appeal is to our own sense of equilibrium or freedom of movement or whatsoever it may be; but what we feel in ourselves we read into the objects which we are contemplating. Just as, in painting, our trivial actions are fathered upon an imaginary spatial world and thereby acquire importance and magnitude, so in architecture our reactions, of no moment in themselves, when they serve to vitalize a towering mass of stable stone, arouse emotions that can overwhelm us by their scale and power.

How intentionally do architects employ these emotional forms? That must depend on the architect and the period. The great masters of the Renaissance and, most of all, of the succeeding "decadence" or Baroque period, made a far-reaching study of these forms (though they did not so call them, or so philosophize about them). The restlessness, the turgid pomp, the straining after greatness which characterized the Baroque are not accidents or incidents of stylistic evolution, but intentional emotional qualities. Nineteenth century criticism, with its materialistic and "scientific" *penchant,* saw in the volutes and scrolls and urns and superimposed pediments and the "clumsy" masses of many an Italian Baroque façade only an unnecessary waste of material with irrelevant ornaments run wild and obscuring structural design. But that is to judge from *parti pris,* to beg the question; for it assumes that the aim of good architecture is to express structure and purpose with economy, whereas the Baroque architects were trying to express something quite different. They were not trying to call attention to questions of construction and engineering, but to work upon the human emotion of the passers-by.

There are other critics who complain that these emotional effects are melodramatic, that Baroque greatness is mere bombast and pretentiousness, that the insistence on effect is tedious and out of place in a monumental art. This is a very different angle of attack. It appeals to the canon of taste and with this I have no intention of taking issue; for I do not wish to ask what emotions architecture ought to evoke, but merely to consider what emotions architecture does and can evoke and how this is done. For that purpose the Baroque is a very good period to study,[18] because it is not interested in monumental calm but in the excitation of emotions whose presence and character are easy to detect.

We are awed by the contemplation of mere bulk and size; for we make the comparison with ourselves and realize our own ineffectiveness. The contrast with our own size and weight is essential to this result. Hence it is architecture's business, if she wishes to produce the emotion, to see to it that we shall make the comparison. She must give us "scale," must furnish us with a unit whose size relative to ourselves we know and can appreciate, and make this unit operative as a unit of measurement which we are induced to lay off and repeat until we become aware how many times it is contained in the architectural surroundings. If that repetition appear interminable or confusedly great, the impression of size will be all the stronger.

Artaxerxes Mnemon built himself a colossal throne-room in his palace at Susa. Its appearance of size was not derived solely from the great linear dimensions of the floor and walls, but from the persistent repetition of great columns whose verticality was emphasized by the grooves which ran unbroken from the bases to the great bull-headed capitals bearing the

ceiling-beams. Wherever one stood, one of these columns rose beside him and stretched away above him, so that a direct comparison between human stature and the loftiness of the room was inevitable. Round about on all sides were these same columns, like the trees of a forest shutting in the view, endless vertical lines, all the same, and all enormous. Here was great height immediately to be apprehended, and endlessly and bewilderingly repeated. Truly great would have seemed the king who throned in such a room and commanded its architects and builders.

The interior of the nave of St. Peter's in Rome gives no such sense of vastness. The classic Order there shows the same elements, and the same relations between those elements, that we might see in many other buildings. Standing in the open floor-space, we have little from which to measure size in relation to ourselves. What unit we may derive, is repeated in a quiet and ordered way for a certain number of times. With no immediate apprehension of size, and no uncounted repetition of greatness, we have little but our reason to tell us that we are in a hall of vast extent and height.

I have taken sense of size as an example, because it is easy to see that it depends not wholly on actual dimensions but on something in the arrangement and distribution of the architectural elements. It is the readiest and most persuasive instance of the effect which a purely formal principle may have upon our attitude toward a building. But it is easy to convince ourselves that formal laws play a very extensive rôle in our most every-day impressions of architecture. Buildings are "top-heavy," "crooked," "forbidding," "attractive," "sombre," "full of energy," "magnificent," "stiff" (to use only a layman's vocabulary and a layman's range of emotions). Why do

they give us these feelings, and why are most of the epithets derived from analogies with our own bodily conditions? If we ask ourselves these questions, we shall little by little come to think of architecture not as mere ornamented engineering but as embodied emotion of a very peculiar sort, a new language speaking to us very directly and very intimately.

If we ask whether these forms reside in any special part (as in the mechanics or the linear relations or the chiaroscuro), we shall find that it is not possible to assign one formal rôle to the structural elements and a different rôle to the "accessory" elements of ornamentation and decoration. Effects of line may be due both to structure and to carving or coloring; surfaces may be structural units or merely colored areas or both at once; ornament which could have been dispensed with from the point of view of the mechanical structure, may be of the utmost importance for the design—like the great S-shaped scrolls of Santa Maria della Salute in Venice, whose shape is not essential to the function. The form of the mullions in the window-tracery may be the most telling source of emotional effect which a stylistic period may have produced. Architectural historians sometimes resent a division of English Gothic into geometric, flowing, and perpendicular periods on the basis of window-tracery forms; but is it really so superficial and amateurish as they would make out? We can date just as accurately from hood-mouldings and drips or technique of buttressing or vaulting bosses or anything else; but it is not a question of identifying the period or analyzing the style, but of naming these according to their most effective characteristic. And this is well epitomized in the tracery.

Ornament or detail can be considered irrelevant only when it has no function to perform, and inappropriate only when

its effect is inappropriate in the whole effect of the building. It may be structurally superfluous and yet formally essential. Even a false façade may be pardoned when it does not aim to deceive. If the Tuscan builders intended to fool the passer-by into thinking that there was a greater and higher church behind the façade than they had really built there, they must have been simple-minded in crediting the public neither with curiosity nor with legs. But if they meant merely to make a fine front to their church, as one might use gold and leather and make a fine cover to a book, their fault was wholly pardonable; for they missed merely the refinement of taste which makes a façadal design appropriate by deriving it out of the exigencies of the nave and aisles which are there terminated. Again, St. Peter's has a "false" dome for appearance's sake! But what is that save an admission that the outside and inside surfaces of the same curvilinear form were felt not to be appropriate to both exterior and interior at once? If one shape suited within and a different one suited without, so build it! There is no deception intended; and the structural waste and additional cost are part of the price of the intended effect. Only if an equivalent effect could have been produced without resorting to such a device, would exchequer and good sense be right in protesting.

So considered, ornament will be seen to be not an accessory or separate element, but an integral part of the builder's art. For this reason it will often tend away from pictorial representation in order that it may be accepted in a more intimate union with the other elements.

Greek architectural ornament was largely drawn from forms of leaf and flower. In the cymatia, these leaf-forms are so conventionalized as to make their botanical prototypes unrecog-

nizable. This is partly due to the fact that they were inherit-ances, with a long history that leads to the Orient and Egypt. No ordinary eye can see a flower in the volutes of the Ionic capital or leaves in the egg-and-dart on its echinus; yet these are very probably the ultimate ancestors. But Greek archi-tecture itself contributed to conventionalizing its decorative forms. Though the acanthus leaves of the Corinthian capital are often carved with very considerable fidelity to botanical prototypes, their whole arrangement and profile prohibit any representational illusion. And Greek architecture was quite content to keep its traditional conventionalizations rather than to discard them for new and more imitative versions.

At times, more representational elements threatened to intrude. The Doric columns, it will be remembered, hold up their oppressive load and with an almost human analogy give, in their entasis, a visual suggestion that the inanimate stone felt the strain of bearing up architrave, frieze, and cornice. They are like Atlas holding the broad sky on his shoulders. The suggestion to carve these supports into the likeness of human figures lay therefore palpably close at hand. Now the basic impulse may have been a tendency to ascribe human characteristics to inanimate objects, to look on a column as though it were a living being; but the formal purpose is slight-ly different, for on being shown a fictitious strain-under-pressure in the column, by analogy with our own feelings at supporting a heavy burden, we experience an emotional, and not merely a reasoned or intellectual appreciation of the pur-pose and structural function of the column. And when the Greeks actually carved giants bowed under the superincum-bent load or maidens standing strong-hipped and stiffly straight with the burden on their heads they may have diminished

rather than heightened the effect. If a more or less abstract form can suggest physical strain, we lose instead of gaining when we substitute for that abstract form a concrete represen- tation borrowed from the actual world.[19] I take it to be an astonishing instance of the power of artistic instinct that, with- out ever very thoroughly reasoning the matter, architectural taste has steadily contested the repetition of this experiment and has tended to eliminate representational shapes from every important structural position.

Of a similar sort is the insistence that vegetable form should be conventionalized, and that actual picturing of the seen world must be confined to structurally minor surfaces. But it will be objected that the Greeks carved and painted pictures for their metopes; that the Panathenaic frieze of the Parthenon is one of the great achievements of sculpture; that Byzantine architecture revelled in mosaics; that Romanesque and Gothic architecture are full of carven beasts and statuary. Clearly the prejudice against mixing the representational with the unrep- resentational is not very thorough or far-reaching.

The real objection, I think, is not against combining repre- sentational with unrepresentational art, but against allowing representation to obscure or destroy formal values. Variega- tions of color (apart from what they depict) have an im- portant formal function. Color is not an accessory or a luxury to architecture. How much does not the little Place des Vosges in Paris owe merely to the red of its bricks, which charms us so simply and cheerily after the arid grey-whites of Champs- Elysian pretentiousness in stone? And are we not carried deep into the very emotional core and spirit of mediaevalism merely by the colors of a Byzantine interior or by that lavish use of reds and blues and purples and greens and golds which so

often covered the entire front of Gothic churches, but whose original presence we of today are always forgetting because we see only the "architecture," the building without the color? But color can even affect the structural aspect. Find a blank wall and cover the upper third with patches of brilliant color if you would see its mere physical weight lessened. Or consider the arrangement of horizontal bands of ever-lightening color on the Palace of the Doges. Or look again at the Panathenaic frieze to notice how the sculptural lines lead the eye along and bind the Parthenon about, as a ribbon holds a bundle together. Again, color is a magnet to the eye and can bend back our heads and take our vision aloft quite as quickly and well as the guiding lines of a moulded pier or the branching ribs of a vaulting.

Thus the mere occurrence of carving and color need not obscure or destroy the formal values, but may itself perform a formal office. There remains the difficulty that this color or carving is not mere color and line, but makes pictures of things irrelevant to the architectural structure of the building. In mediaeval times, these pictures were part of an attempt to wed understanding with architectural emotion. When the eye had imparted directly the emotions inherent in the wonderfully lined and balanced, shadowed and colored structure, and aroused through architectural form something emotionally comparable to a sense of striving and attainment, patience and perseverance, wealth and rejoicing, gloom and terror and triumph, it was the turn of the intellect to read the illustrated book of saints and martyrs, angels and devils, with their recollection of trials and virtuous deeds, and to wed these emotions of the intellect with those simpler, more primitive ones of the unreasoning apprehension. In Greece, too, the

contemplation of heroic adventures and divine legends was intended to satisfy the reasoning curiosity and to offer its more sophisticated appeal as a supplement to the direct working of architectural form. For, in both cases, architecture was toiling in the interest of religion; and the ultimate channel of its emotions lay beyond its own domain.

We have seen that the initial barrier to an understanding of architectural esthetics lies in our own insistent assumption that the art is governed by practical utility, whereas insofar as architecture is an art it has almost nothing at all to do with practical utility. This dogma will always be hotly contested. "Is not architecture the art of building, and are not buildings primarily dwelling-places with walls to give shelter, roofs to exclude rain, windows to let in light, and plans arranged for specific human needs? and do these not depend absolutely on the practical laws of engineering and gravitational mechanics? How then can you say that it has nothing to do with utility?" But this is merely to say that architecture is a practical activity first and an art only secondarily. Insofar as it *is* an art, it has almost nothing to do with these practical demands. As an art, it is a spatial presentation of solid forms, aiming at no imitative pictorial illusion, but appealing primarily to our gravitational sensibilities and our powers of spatial apprehension and secondarily to certain activities of visual comparison and construction which we call geometric when they are viewed by our intellect, but for which we have no good name (unless it be Artistic Pure-Forms) when they are apprehended through our esthetic sensibility.

"But," I hear some one say, "you must be a good engineer to be a good architect," or again, "this so-called esthetic architecture is all very well on paper; but wait till you try building

it," or, "when a city orders a municipal court-house, does it want spatial presentations and appeals to the gravitational sensibilities of the tax-payers, or does it want a good service-able court-house?"

Most of the arts were originally slaves to practical ends. Poetry had to chronicle or instruct or placate; sculpture had to serve religion or superstition or human self-glorification; similar tasks were assigned to painting; but all these, even from the earliest time, seem also to have existed in their own right, because what they did was directly pleasing to men. Even in the popular mind, poetry has emancipated herself of any ulterior end or service; sculpture and painting are for the delight of what they show; but architecture for the most part still stays in bondage. Her works are too costly and too un-wieldy to be produced for mere contemplation; and since they are unrepresentational, men have seldom seen what such works might be intended for, if not just to house men and their chattels with perhaps a fine external show of wealth. Perhaps because of this popular blindness, though we may have laid a thousand stones to antiquity's one, we make no greater art of our architecture than did the ancient builders. Indeed, if subtlety, refinement, perfection of proportion, clarity of form, sensitiveness to outline and surface and the visual appearances of weight in equilibrium, if all these are criteria of artistic accomplishment, twentieth century America has not even re-motely rivalled the builders of ancient Greece.

BIBLIOGRAPHICAL NOTE

A BRIEF BIBLIOGRAPHICAL NOTE

THERE ARE practically no discussions of Greek art written in English and dealing more than incidentally with the subject of the present volume. There are several summary collective accounts of the various arts, among which Percy Gardner, *The Principles of Greek Art* (London, 1914; reprinted, 1926) and H. N. Fowler and J. R. Wheeler, *Handbook of Greek Archaeology* (New York, 1909), though seriously out of date, still have much information to offer those unacquainted with the material. But the reader who desires to penetrate deeper into the What and Wherefore of Greek artistic behavior would be well advised to devote himself to acquiring accurate knowledge of some restricted domain rather than attempting an unavoidably superficial and hence probably misleading review of the entire accumulated material.

For the three major arts the standard handbooks in English are:
for architecture, W. B. Dinsmoor, *The Architecture of Ancient Greece* (Batsford, London, New York, etc., 1950).
for sculpture, G. M. A. Richter, *The Sculpture and Sculptors of the Greeks* (Yale University Press, New Haven, 1950).
for painting, M. H. Swindler, *Ancient Painting from the Earliest Times to the Period of Christian Art* (Yale University Press, New Haven, 1929).
E. Pfuhl, *Masterpieces of Greek Drawing and Painting* (New York, 1926).

In order to branch out from these, the remarkably extensive bibliography on pages 341-386 of Dinsmoor's handbook will be found to have listed almost everything of importance for the study of Greek architecture and, in addition, much else in allied fields. The difficulty will be one of choice among so much; but the orderly

classification under topics and sites permits an otherwise unguided penetration into this discouragingly vast domain of professional writings. Dinsmoor's handbook itself hardly transgresses a strictly factual level of authoritative information; but herein remains without even a *proxime accessit* among other writers on the subject.

In sculpture, among the more restricted studies which are especially repaying may be listed:

S. Casson, *The Technique of Early Greek Sculpture* (Oxford, 1933).

C. Bluemel, *Greek Sculptors at Work* (Phaidon Press, London, 1955).

G. M. A. Richter, *Kouroi* (Oxford University Press, New York, 1942).

M. Bieber, *The Sculpture of the Hellenistic Age* (Columbia University Press, New York, 1955).

Even those without direct access to the museums in Boston and New York will find extremely informative the discursive catalogs of the collections of classical sculpture by L. D. Caskey (for the Boston Museum of Fine Arts) and G. M. A. Richter (for the New York Metropolitan Museum). Those desiring good illustrations to accompany their theoretic consideration of Greek sculpture will find a picture album of outstanding photographs in Lullies-Hirmer's recent book, *Greek Sculpture* (Abrams, New York, 1957). Furtwaengler's renowned *Masterpieces of Greek Sculpture* (London, 1895) is rewarding mainly to the specialist who can evaluate its brilliant accomplishments and no less brilliant errors. In French, C. Picard's monumental survey, *Manuel d'archéologie grecque, la sculpture* (Paris, 1935—still in course of publication) replaces his earlier works and gives more extensive and intimate detail than can be found in any other single compilation. Being French, it is eminently readable.

For vase-painting, Sir John D. Beazley exhibits the highly exceptional phenomenon of combining an incredibly detailed knowl-

edge of his subject with an ability to write about it with breadth and brilliance. The student would do well to inform himself in advance for any given work, to which of these two aspects of his genius it belongs. Among those writings intended to be generally read, as well as to be studied by the expert, may be mentioned:

Attic Black-Figure, A Sketch (Milford, London, 1928).

The Development of Attic Black-Figure (University of California Press, Berkeley, 1951).

For red-figure Attic ware there is an excellent introduction in:

G. M. A. Richter, *Attic Red-Figured Vases, A Survey* (Yale University Press, New Haven, 1958).

Most of the Greek minor arts come off rather poorly for the unspecialized reader. Between the brief factual surveys without much scope of understanding and the specialized treatises, which understand only too well the arcana of research study, there is little of note except for coinage, where the general classicist is fortunate in having the work of Sir G. F. Hill, notably:

Coins of Ancient Sicily (Constable, London, 1903).

Historical Greek Coins (Macmillan, New York, 1906).

Select Greek Coins (enlarged photographs) (Vanoest, Paris, 1927).

A companion picture-book to the last is K. Lange's *Herrscher-koepfe des Altertums* (Berlin, 1938). There is also C. T. Seltman's *Masterpieces of Greek Coinage* (Cassirer, Oxford, 1949). But most of the Greek numismatic literature is too specialized to be generally useful, as may be realized by glancing at the bibliography listed by Seltman in his handbook, *Greek Coins* (Methuen, London, 1915).

Ars longa, vita brevis; but the real difficulty is not so much in Art as in that which has been written and said about it. No scholar can any longer read all that is printed or keep himself abreast of all that is transpiring. Those wishing to make the attempt will find guid-

ance in the annual summaries of recent discoveries and the current reviews of new books which appear in the *Journal of Hellenic Studies* in England and the *American Journal of Archaeology* in this country. In the last analysis, few of those who have devoted themselves intensively to the study of Greek art have ever complained that their expenditure of time and energy was ill-advised or unrewarding.

NOTES

NOTES

CHAPTER I

1. I could wish that writers on esthetics would be more mindful that this is so, and that with all artistic illusion (if it be truly artistic) there is fused to some degree the sensibility that illusion is different from reality. This applies to all the imitative and presentational arts, whether of the theatre or the atelier; and it needs no very great attention to discover that every art protects its title to artistry by clinging to certain conventions which will obviate complete and full illusion. The theater has its curtain and footlights and a host of conventions of acting; sculpture eliminates color, or rather chromatic fidelity; painting must make (and particularly delights in making) its own spatial world of illumined objects, and so need seldom trouble itself with the fear of too illusionary a content; the minor arts are ever conscious of the gold or silver or bronze or ivory or precious stone in which they work, and at their best are least ashamed of the peculiar and native qualities of their media.

2. It cannot be without significance that so many languages apply human corporeal terms such as "foot" "mouth" "lip" "body" "belly" to the various parts of vases and jugs and pitchers. Although this may betoken insufficiency of technical vocabulary, nevertheless, since metaphor illuminates mental processes, we are entitled to discern the working of an instinctive animism in such a trait. The Greek ceramic vocabulary was in some respects even more animistic than our own: where we speak of a jug's "handles" (with implied reference to our own hands' functioning), the Greek spoke of "ears" (as though the living jug possessed these organs).

3. Perhaps the landscapes of Chinese painting will best suggest the direction which Greek art might have taken in a less luminous and more misty climate. There is the same scrutiny of individual forms, the same indifference to the merely optically correct, the same intellectualization and artistic rethinking of objective appearance, the same extreme fidelity to the ideal content.

CHAPTER II

1. There is a possible confusion here which ought to be avoided. The particular run of a line may suggest that the thing which it helps to represent is in motion. Lines of an appropriate contour will make us see a dog running, a bird flying. Such lines present motion, *i. e.,* motion in the represented object. But the motion which is a formal function is not in the picture so much as in ourselves. There might be a greater use of formal motion in a still-life picture than in a representation of objects supposedly in very rapid motion, *e. g.,* a photograph of a galloping hourse.

2. This is quite in accord with later Greek estimates of the early painters. Compare, for example, the following passage from Dionysius of Halicarnassus (*de Isaeo judic.* 4): "In ancient painting the scheme of coloring was simple and presented no variety in the tones; but the line was rendered with exquisite perfection, thus lending to these early works a singular grace. This purity of draughtsmanship was gradually lost; its place was taken by a learned technique, by the differentiation of light and shade, by the full resources of the rich coloring to which the works of the later artists owe their strength." (Trans. Jex-Blake.)

CHAPTER III

1. . . . *the mere contours will make them intelligible.* Cf. Pliny (*N. H.,* xxxv, 67–8): ". . . rendering of outline. This is the highest subtlety attainable in painting. Merely to paint a figure in relief is no doubt a great achievement, yet many have succeeded thus far. But where an artist is rarely successful is in finding an outline which shall express the contours of the figure. For the contour should appear to fold back, and so enclose the object as to give assurance of the parts behind, thus clearly suggesting even what it conceals." (Trans. Jex-Blake.)

2. *Polykleitan statues are too "square."* Cf. Pliny (*N. H.,* xxxiv, 56): *"Quadrata tamen esse ea ait Varro."*

3. *N. H.,* xxxiv, 65.

4. In addition to this rotation of the axes in a horizontal plane, a vertical displacement of these axes occurs in more complicated poses such as those of sitting or crouching or recumbent figures. It will be found that this, too, is an ordered and regular process contributing in a similar manner to the same end.

5. There is a possible quibble here which I mention, if only to show that I have not overlooked it. The third dimension in normal geometric space

stretches away in parallel planes. In visual space its planes all intersect in the eye and therefore cannot be parallel but must be radiate like the lines from a vanishing point in perspective drawing. The invisible third dimension of which I have been speaking in connection with the spatial extension of sculpture refers to this third or radiative dimension in *visual* space, and should be so understood.

6. Though not in the form nor to the extent postulated by Mr. Jay Hambidge in his *"Dynamic Symmetry."*

7. Galen, *de Plac. Hipp. et Plat.*, 5.

8. περὶ βελοποιικῶν, iv, 2.

9. "I make the rule always one-sixth of the length of the figure . . . then I divide the rule into ten equal parts and each part I call a *zall*, each *zall* I divide into ten and call each tenth a *teil*, each *teil* into three and call each third a *trümmlein*." Here are indeed "many numbers." The smallest unit of division is one 1800th part of the total height of the figure!

10. Pliny, *N. H.*, xxxiv, 65.

11. Quint., xii, 10, 7.

12. However, it should be remarked that Pliny's verdict presumably does not reflect an esthetic judgment, either his own or transcribed from one of his sources of information. Pliny seems to have made extensive use of a chronicle of Greek sculpture compiled by the Lysippan sculptor Xenokrates. Since such a chronicle necessarily ended with Xenokrates' own time, it was this account (and not the whole art of sculpture) which broke off at the period set by Pliny. If Pliny supposed that no Greek sculpture was produced between the early third and the middle of the second century B.C. (at which point he asserts that sculpture again came to life—*rursus revixit*), the lacuna must be sought in his sources of information rather than in the art which ancient Greece fostered and admired above all others.

CHAPTER IV

1. *The Greeks were timid engineers.* Consider the elaborate precautions taken with the central span of the Propylaea (W. B. Dinsmoor in *American Journal of Archaelogy*, 1910, pp. 145 ff). By applying the modern engineering formulae given in Kidder's *Architect's and Builder's Pocketbook*, I find that these precautions were superfluous.

2. *These columns were . . . but barely sixty feet.* Cf. Athens, Olympieum; Miletos, Didymeum; Ephesos, "fifth" or Hellenistic temple of Artemis.

3. Contrast the rich inventions of plan in late Roman times (Montano, *Scielti di varii tempietti antichi*, and *Raccolta di tempii*, etc.).

4. πόλις κακῶς ἐρρυμοτομημένη. Dicaearchos I.1.12.

5. I do not accept Dörpfeld's suggestion of an original symmetrical plan doubled on a north-south axis.

6. Cf. for example Dinsmoor's plate showing the evolution of the Ionic Order of Asia Minor (A.J.A., 1908, p. 4); but cf. also Marquand, *Greek Architecture*, p. 131 *infra*, ". . . the Greek love of variety, which makes it impossible to appy the rule mechanically so as to establish an exact chronological series." For Greek architectural mouldings the two treatises by Dr. Lucy T. Shoe (*Profiles of Greek Mouldings* and *Profiles of Western Greek Mouldings*) are without rival.

7. Cf. Koldewey and Puchstein, *die griechischen Tempel in Unteritalien und Sicilien.*

8. . . . *they left no straight line straight.* The material for the study of this question is to be found in Penrose, *Principles of Athenian Architecture* and Goodyear, *Greek Refinements.*

9. . . . *not optical corrections.* Goodyear has abundantly proved this point in the book referred to in the previous note.

10. Cf. T. A. Cook, *The Curves of Life;* d'Arcy Thompson, *Growth and Form;* A. H. Church, *Relation of Phyllotaxis to Mechanical Laws;* and the two (very popularly written) books by S. Colman and C. A. Coan, *Nature's Harmonic Unity* and *Proportional Form.*

11. *Mausoleum.* I am here following the measurements and calculations of W. B. Dinsmoor (A.J.A., 1908, pp. 1-29) rather than those of Lethaby (*Builder,* Feb. 6, 1920, p. 168; Sept. 3, 1920, p. 256).

12. *The lions' heads . . . are so placed.* This arrangement is certain for the Athena temple at Priene and quite possible for the Mausoleum.

13. It should be noted, however, that the frieze was not an original member of the Ionic Order and was very generally absent from East Greek buildings.

14. *Commensurable but not measurable relations, i. e.,* commensurable in terms of simple integral numbers and ratios, but not measurable in feet, palms, and dactyls without fractional parts.

15. Marquand, *Greek Architecture,* pp. 144-5.

16. Goodyear, *Greek Refinements.*

17. In Mr. Donald Tovey's article *Music* in the Enc. Britt. (XIth Ed.) by a curious coincidence a metaphorical comparison is made between Greek music and an art of two dimensions. The analogy is of course intended only in a figurative sense, but deserves at least a passing reference here: "Non-harmonic music is a world of two dimensions, and we must now inquire

how man came to rise from this 'flatland' to the solid world of sound in which Palestrina, Bach, Beethoven, and Wagner live."

18. *The Baroque is a very good period to study.* I wish to acknowledge very great indebtedness to Geoffrey Scott's *Architecture of Humanism* for my general position on the esthetics of architecture.

19. This seems to be inconsistent with what was said in the chapter on Sculpture. The point of the argument is the contention that in the case of a Caryatid we may appreciate strain and weight in terms of a human bodily experience within ourselves (precisely as in any other statue) but we are unable to ascribe them to the building. The empathy is sculptural, not architectural.

TOPICAL INDEX

TOPICAL INDEX

I. GREEK ART

175

II. ARTS OTHER THAN GREEK

III. ESTHETIC THEORY